EDUARDO PAOLOZZI (1924–2005) was one of the greatest Scottish and European artists of the 20th century. He was a prolific sculptor and printmaker as well as an inspirational teacher. His was an exceptional talent, drawing on culture in all its forms, from classical myths to comics and ephemera. Most would agree he was the originator of the Pop Art movement.

He was born in Edinburgh into an immigrant Italian family whose origins were in Viticuso, a *comune* (municipality) in the Province of Frosinone in the Italian region Lazio, about 130 kilometres southeast of Rome. They ran an ice cream and confectionary shop in Albert Street, Leith. There was no 'silver spoon' or patronage available, only ingenuity and dedication.

Despite having lived and worked in the cosmopolitan art worlds of London, Paris, Berlin, New York and Osaka, his native city is where you will find not only some of his most arresting work but also a demonstration of the breadth of his creativity: from colossal bronzes to subtle stained glass. Although some of his work is archived in the University of Edinburgh, or held privately, most is displayed as public art or exhibited in the National Galleries.

Paolozzi at Large in Edinburgh

artworks and creative responses

Edited by Christine De Luca and Carlo Pirozzi

Luath Press Limited
EDINBURGH
www.luath.co.uk

First published 2018

ISBN: 978-1-912147-83-3 Hardback
ISBN: 978-8-912147-88-5 Paperback

The paper used in this book is recyclable. It is made
from low chlorine pulps produced in a low energy,
low emissions manner from renewable forests.

Printed and bound by Bell & Bain Ltd., Glasgow

Typeset in 10.5 point Quadraat by 3btype.com

Contents

Notes and Acknowledgments – Carlo Pirozzi 7

Foreword – Carlo Pirozzi 11

Introduction – Fiona Pearson 13

Paolozzi Chronology – Kirstie Meehan 14

Part One

Work in Progress – Andrew Patrizio 19

Tottenham Court Road Tube Station Mosaic
Arch Fragments – Liv Laumenech 27

Master of the Universe – Bill Hare 35

Paolozzi Maquettes – Fiona Menzies 43

The Manuscript of Monte Cassino –
Robin Spencer ... 51

The Wealth of Nations – Elly Thomas 61

Parthenope and Egeria – Judith Collins 71

Portrait of Josephine Baker – Lucy Weir 81

Early People – David Clarke 89

Vulcan – Kirstie Meehan 99

Millennium Window – Duncan Macmillan 107

Studio Reconstruction – Fiona Pearson 119

Part Two

Twelve conversations with Sir Eduardo Paolozzi
– introduced by Colin R Greenslade 129

Michael Agnew RSA 132

William Brotherston RSA 134

Alfons Bytautas RSA 136

Doug Cocker RSA 138

Michael Docherty RSA 140

Graham Fagen RSA 142

Paul Furneaux RSA 144

Eileen Lawrence RSA 146

Jim Pattison RSA 148

Alan Robb RSA ... 150

Michael Visocchi RSA 152

Arthur Watson PRSA 154

Biographies ... 156

Note and Acknowledgements

Paolozzi at Large in Edinburgh – co-edited with Christine De Luca – and the accompanying exhibition at the Royal Scottish Academy (RSA) in Edinburgh, is part of my Eduardo Paolozzi (EP) Project, an *hommage* to one of the greatest Scottish and European artists of the 20th century.

This multi-disciplinary EP Project began with this book which includes reproductions of 12 of Paolozzi's major artworks in Edinburgh, alongside 12 poems written in response by Christine De Luca, with translations into Italian by Francesca Romana Paci. For each of the artworks featured, there is also an accompanying creative commentary written by a prominent researcher or arts commentator, as well as more personal reflections by the writer Vivian French, whose brother, Ray Watson, was – for 30 years – Paolozzi's main assistant and model maker.

Paolozzi was an honorary member of the RSA, so it is fitting that the second part of the book includes reproductions of artworks by current members of the RSA, created in response to Paolozzi's principal themes.

I would like to retrace how the idea for this book was born and then evolved with the support, generosity and skills of those who made valuable contributions to the project.

Initially my idea was to commission Christine De Luca to write poems in response to the artworks by Eduardo Paolozzi in Edinburgh, alongside commentaries by one of Paolozzi's closest friends, Robin Spencer, a well-known art historian who had written extensively on the artist. Robin's sudden death soon after the start of the project was a real set-back but, with the kind permission of his partner, Karen Moore, we were able to use Robin's single commentary as a helpful template in terms of approach, audience, length and style.

I will always remember with gratitude Robin's kindness in inviting Christine and I to meet him in York, where we enjoyed a long chat over lunch, with Robin offering an illuminating perspective on the artist and on our project as he enthusiastically reminisced about Paolozzi.

Among the many people who have contributed to this project, first and foremost I must mention Christine and her enormous and invaluable contribution, not only as distinguished poet, but also as tireless and careful co-editor, and as unique collaborator in developing aspects of my EP Project beyond this publication.

We are particularly indebted to Andrew Patrizio and Kirstie Meehan, who contributed the Paolozzi chronology. Andrew and Kirstie kindly agreed to participate in the publication as authors and were enormously helpful in identifying researchers willing to take part in this specialist task. The group of people we managed to assemble, with their help, is impressive and we are indebted to them all: David Clarke, Judith Collins, Bill Hare, Liv Laumenech, Duncan Macmillan, Fiona Menzies, Fiona Pearson, Elly Thomas and Lucy Weir.

We are very grateful to Francesca Romana Paci, who had previously translated Christine's poetry, for her splendid versions of the ekphrastic poems in Italian, adding a special texture to the book and reflecting Paolozzi's Scottish-Italian background.

The book would not have been complete without some reference to the legacy of Paolozzi as artist and teacher. We would particularly like to thank the RSA Director, Colin Greenslade, who was more than helpful in collecting images of work created by academicians in response to Paolozzi's *oeuvre* and writing an introduction to their works. We are indebted to each of those artists: Michael Agnew, William Brotherston, Alfons Bytautas, Doug Cocker, Michael Docherty, Graham Fagen, Paul Furneaux, Eileen Lawrence, Jim Pattison, Alan Robb, Michael Visocchi and Arthur Watson. We are also very grateful to Colin, and his supportive staff, particularly Flora La Thangue, for their generous help with organising and hosting the launch of the book and the EP Project at the prestigious RSA Galleries in October 2018.

Finding appropriate images has not been straightforward but we wish to acknowledge the help of the University of Edinburgh Art Collection staff, the National Galleries of Scotland (NGS), the

National Museum of Scotland, the Royal Bank of Scotland, the City of Edinburgh Council, St Mary's Episcopal Cathedral and the photographers Dave Sands and Luigi Giannetti. Special thanks to Ray Bird for his powerful image for the front cover of the book.

We are delighted that Fiona Pearson agreed to write an introduction – she worked with Paolozzi over many years in her role as a Senior Curator at NGS – and that Vivian French was happy to write 'behind the scenes' sketches to enliven the text.

We would like to express our gratitude to the Paolozzi Foundation, in particular to Toby Treves, who very kindly granted permission for us to reproduce all Paolozzi's works.

The EP Project has generated many creative offshoots. The first of these was the creation of an interactive map, which will feature on the Edinburgh World Heritage website, identifying artworks by Paolozzi and locations linked to his early life in the city. Special thanks to Helga Pavelkova who created this wonderful Paolozzi-inspired touch: we have been able to use it for both the endpapers of this book and for the home page of the EP Project Map website. It is an honour that Edinburgh World Heritage funded part of the EP Project and developed the website linked with this publication.

All artworks featured on this interactive Edinburgh 'map' will be accompanied by links to original podcasts of some of the poems by Christine De Luca, as well as new creative responses written by other writers, including a fascinating short story by Alexander McCall Smith. Each location on the map connected to Paolozzi's life will link to recordings of his friends, family and colleagues reminiscing about the artist, and discussing his powerful presence in the city. These include his sister, Yolanda, the writer Vivian French, and the well-known artist and arts promoter Richard Demarco.

The EP Project will continue to create and to promote new artworks inspired by Paolozzi, including work by students, communities and artists. One upcoming part of the project is a series of 'Paolozzi walks' in Edinburgh and we would particularly like to thank Ken Cockburn for developing this. We would also like to thank Colin Waters from the Scottish Poetry Library for recording and editing podcasts.

All parts of the EP Project – strongly inspired by Paolozzi's way of making art as a creative process that 'never stops' – are featured on the University of Edinburgh's Italo-Scottish Research Cluster (ISRC) website, directed by Federica Pedriali and coordinated by myself. The ISRC, funded through a Large Research Grant from the Carnegie Trust for the Universities of Scotland (2012–2013), is the first online archive in the UK to preserve historical documentation relating to the Italo-Scots, and to develop projects and collaborations between Scotland and Italy. Italo-Scots form one of Scotland's largest immigrant communities over the last 150 years.

Special thanks to Kirsty Dunsmore, Head of Marketing at the Edinburgh Beer Factory, for her support since the beginning of the project and for sponsoring the initial launch of the book. The Edinburgh Beer Factory is a family run, independent brewery founded in 2015 by the Dunsmore family.

Special thanks to Lucinda Byatt (University of Edinburgh) for her splendid translation of my brief foreword.

A huge 'thank you' from Christine and me to all involved in the Paolozzi at Large in Edinburgh book. This must include our publisher, Gavin MacDougall of Luath Press, for his faith in this project, and his staff for their diligence and helpfulness.

Last but not least, I would like to mention a few more people who have played an important role in helping me personally to develop all these projects on Paolozzi, starting a few years ago.

I am particularly indebted to Margaret Rose (University of Milan) who strongly inspired me to work on Paolozzi.

I am very grateful to Charles Burdett (University of Bristol) and Derek Duncan (University of St Andrews) with whom I previously worked on the

innovative and challenging 'Transnationalizing Modern Languages' Project (founded by the Arts & Humanities Research Council, 2014–2017). They also supervised my research on the Italo-Scots community.

I would like to express my gratitude for the unfailing support, encouragement and guidance of Davide Messina (University of Edinburgh), with whom I am now working as Teaching Fellow in the vibrant Italian Department.

Finally, I dedicate *Paolozzi at Large in Edinburgh* to my current Department in the University of Edinburgh which, during the Academic Year 2018–2019, is celebrating the Centenary of the first Italian Studies department in Scotland, formally created in 1919.

<div align="right">Carlo Pirozzi</div>

THE CITY IS A metaphor of humankind and its languages, or more precisely of the inseparable bond between *humanitas* and *polis* that determines the sense of belonging to a precise place, and to a culture and a language.

If the city is a place of identity, then to the foreign and familiar eyes of the person writing, who first arrived in this city ten years ago, Edinburgh has always appeared as a place of bewitching yet alienating charm, owing to its special beauty, its sweeping skyline and the unusual sensation it offers of being unlike any other city. It is easy to lose oneself among the narrow, light-filled closes that thread through the tall, curving streets, forming one of the most beautiful medieval and gothic city centres, the Old Town. This leads and finally merges into the geometric plans of the Georgian New Town, creating a heady sense of plunging towards the coast whenever the typical soot-coloured sky inks the sea in the same hue, erasing the horizon and setting the scene, accompanied by the raucous mewing of gulls, for the world's end.

In this typically Scottish scenario, even at a distance from Hadrian's Wall which decreed its non-existence, and while still preserving its distinctive, monolithic nature, proud of its deep roots, Edinburgh is amazingly open; it extends a unique if slightly reserved welcome – not very tactile but nonetheless hospitable and gentlemanly, neither selective nor overly obsessive – to the disconcerting invasion of artists and visitors from all parts of the world whom it hosts every summer.

It was while I was walking through Edinburgh in the guise of an unwitting *flâneur*, feeling strangely at home but at the same time disorientated, simply because the surrounding space was so different to that of my native country, that I came across an enigmatic sculpture, *The Manuscript of Monte Cassino* by Eduardo Paolozzi, a powerful artwork composed of three colossal body parts – a foot, an ankle and a hand – then sited outside St Mary's Metropolitan Cathedral but now relocated to Hillside Crescent Gardens.

This was perhaps the moment when the idea was born that eventually grew into this book. I recognised an object that belonged to my own Italian culture, but was at the same time foreign to it. It was an object that was completely out of place in this particular urban setting, like a meteorite that had plummeted from another world, fusing the space around it and allowing the observer to contemplate it in total solitude, full of amazement.

How can this artwork reveal a sense of belonging (or not) and in relation to what identities, what backgrounds? Where is it from? How does Paolozzi's artwork trace and reformulate an Italian identity or a Scottish/English/British one in response to either his Italian cultural background or his homeland?

Paolozzi has been seen as an 'outsider', a 'maverick', as some critics have written, even if he described himself as 'a curious kind of European hybrid on the English landscape'. And *The Manuscript* and the other powerful works presented here and displayed in Edinburgh, a city that seems to house and protect them with extraordinary reverence, reveal a unique, hybrid beauty whose provenance seems hard to trace.

They are objects made by quasi-divine hands, I would say – transcultural, transnational objects, or objects from another world – which only a giant in the Olympus of art, like Paolozzi, could create and, in this case, gift to his native city, as if they were emblematic signals of a future that is already present, marked by profound, and continuous cultural and artistic contaminations which overturn and shape the skyline of the world.

Paolozzi at Large in Edinburgh pays *hommage* to this prodigious artist and his works through an ambitious and innovative collage of poetry, translations, comments and artworks which dialogue with the enormous legacy left by the artist to his native city, Edinburgh. In the same way that, for Paolozzi, collage was much more than a technique, and indeed represented the real essence of his art, the present volume tries to emulate that audacious gesture of assembling and juxtaposing different

languages and images, inviting the reader to discover both the wonder of the artist's works and the endless creative short-circuit that was sparked by admiring them.

Now that the book is done, that short-circuit continues to generate other stimulating new artworks and increasingly explosive ideas, because Italo Calvino was right when he said in *Invisible Cities*, 'rarely does the eye light on a thing, and then only when it has recognized that thing as the sign of another thing'.

Carlo Pirozzi

Introduction

THIS CELEBRATION OF Eduardo Paolozzi's works in Edinburgh through the evocative poetry of Christine De Luca has brought together many people who either knew or are inspired by the artist. It is a project he would have loved being a keen poet himself and a reader of Michelangelo's sonnets. It is a wonderful reminder of the artist's Italian roots and his upbringing speaking peasant dialect Italian, classic Italian, Scots and English.

Paolozzi was a global figure and a visionary. His work touched on all aspects of human endeavour and different cultures. From prehistory to the space age, from tribal artefacts to Leonardo da Vinci, he relished the spark of creativity that runs through all civilisations. It is therefore a real tribute to his teaching skills and mentorships that a large group of members of the Royal Scottish Academy are able to share their works which are supercharged by his example.

The eyewitness account of Vivian French, sister to Ray Watson, Paolozzi's chief assistant, and the explanations of each work or works by scholars bring alive that sense of restless energy which emanated from the artist. His immense curiosity about everything, the sensitive reading of situations and his sometimes brutal responses fed into an ever-changing body of work. Sculptures, collages, prints, books, films, textiles, ceramics, glass, public projects, mosaic, poetry, collage texts, puppets, installations, curated exhibitions, slide lectures, workshops, masterclasses, activism in key issues like ecology and peace were manifest in his life.

Paolozzi was born in 1924 in Leith, the port for Edinburgh, and dreamed in its cinemas, drew the crab fishermen and sculpted horses from the stables at the end of Albert Street where his parents' ice cream and confectionary shop was situated. He gave sculpture to and showed at the National Galleries of Scotland in the early '60s and made his Edinburgh public projects in the 1990s, deciding in 1994 to donate his studio contents to the Scottish National Gallery of Modern Art which had a Paolozzi curatorship from 1994 to 2010. The bequest of Robin Spencer this year to fund a new Paolozzi curatorship and pass on all his Paolozzi papers to the National Galleries of Scotland will ensure a new generation of Paolozzi scholars and fans.

A huge vote of thanks must go to Christine and Carlo for their rich response to the work of Sir Eduardo Paolozzi. Their bringing together the artistic community to pay tribute and to respond to the works in Edinburgh is a reminder of the power of art to make us look anew at the world every day.

Fiona Pearson

Eduardo Paolozzi Chronology

1924	Born at 6 Crown Place, Leith, Edinburgh
1929–1936	Attends Leith Walk Primary School
1936–1940	Attends Holy Cross Academy
1940	Interned for three months in Saughton Prison, Edinburgh, with his father and grandfather as an enemy alien
1 July 1940	Torpedoing of the SS *Arandora Star* en route to Canada resulting in the deaths of Paolozzi's father and grandfather
1941	Enrols at Edinburgh College of Art, initially taking evening classes
1943–1944	National Service in the Royal Pioneer Corps
1944–1947	Attends the Slade School of Fine Art, then situated in Oxford: studies sculpture and drawing
1947	First solo exhibition: *Drawings by Eduardo Paolozzi*, The Mayor Gallery, London, 14 January–1 February
1947	Moves to Paris: met, among others, Jean Arp, Georges Braque, Constantin Brancusi, Tristan Tzara. Enrols at the École des Beaux-Arts
1949–1950	Returns to London and begins teaching textile design at Central School of Art
1951	Marries textile designer Freda Elliott
1952	Shows *Bunk!* at the Institute of Contemporary Arts
1953	Organises the exhibition *Parallel of Life and Art* with Alison and Peter Smithson, co-founders of the Independent Group, and Nigel Henderson
1955–1958	Teaches sculpture at St Martin's School of Art
1956	Exhibits in *This Is Tomorrow* at Whitechapel Gallery, London
1960–1962	Teaches at Hochschule für bildende Künste, Hamburg
1968–1989	Teaches ceramics at Royal College of Art
1971	First major retrospective: *Eduardo Paolozzi*, Tate Gallery (22 September–31 October)
1975	Commissioned by Glasgow University to create the doors for the Hunterian Gallery
1977–1981	Teaches ceramics at Fachbereich Kunst und Design, Cologne
1979	Appointed Royal Academician

1980–1986	Commissioned by Transport for London to create Tottenham Court Road mosaics
1981–1990	Appointed Professor of Sculpture at the Akademie der bildenden Künst, Munich
1984	Eduardo Paolozzi Recurring Themes Exhibition, for the Edinburgh International Festival
1985	Purchase of the 'Krazy Kat Arkive' by Victoria & Albert Museum, London
1986	Appointed Her Majesty's Sculptor in Ordinary for Scotland
1989	Appointed Visiting Professor at the Royal College of Art. Knighted
1991	Unveiling of *The Manuscript of Monte Cassino*, Picardy Place, Edinburgh
1992	*The Wealth of Nations* commissioned by the Royal Bank of Scotland, Edinburgh
1995	University of Edinburgh commissions large bronze figures *Parthenope and Egeria* for the Kings' Buildings
	Donates the Paolozzi Gift to the National Galleries of Scotland, comprising over 2,000 prints, 500 drawings, 9,000 photographs, 3,000 slides and a significant amount of archive material
	Begins work on *Vulcan* for the Dean Gallery (now Modern Two), Scottish National Gallery of Modern Art
1997	Commissioned by the Museum of Scotland to make 12 bronze figures (*Early People*)
1998	Commissioned to create the stained glass windows for St Mary's Episcopal Cathedral, Edinburgh
1999	Opening of the Dean Gallery (now Modern Two), housing the Paolozzi Studio and *Vulcan*, Edinburgh
2005	Dies 22 April
	Eduardo Paolozzi's work continues to be widely exhibited, most notably the retrospective exhibition at the Whitechapel Gallery, London (2017). The Scottish National Gallery continues to mount exhibitions which feature his work eg Warhol and Paolozzi 'I want to be a Machine' at Modern Two (2018)

Part one Paolozzi at Large in Edinburgh

Work in Progress

" Eduardo was a compulsive hoarder and collector of things that might one day 'come in useful'. He and Ray never passed a skip without diving in and inspecting the contents, usually hauling out at least a couple of items. My brother had an old Ford van; it was often stuffed full of miscellaneous bits and pieces that eventually ended up on a shelf in one of EP's studios... or on the floor. Although 1962 is well before Ray's time, I imagine Eduardo enjoyed creating this piece very much. "

Work in Progress – collaboration with RB Kitaj (1932–2007)

DATE: 1962

MEDIUM: Paper and tin collage in painted wooden frame

DIMENSIONS: 85.3 cm x 100.0 cm

PROVENANCE: Bequeathed by Gabrielle Keiller, 1995

LOCATION: Scottish National Gallery of Modern Art, Edinburgh

COPYRIGHT: © RB Kitaj Estate and Trustees of the Paolozzi Foundation, Licensed by DACS

Collection of the National Galleries of Scotland

Photography by Antonia Reeve

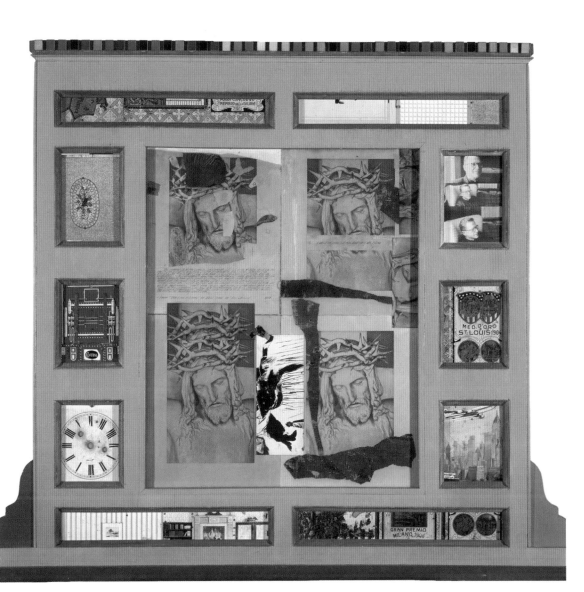

Collage

Perhaps you'd found Kitaj – this outsider to the London set –
a kindred spirit in Pop Art, collage, the textual approach?
You'd collaborate with him, but call the shots:
think up the concept, create the overall design, select
signifiers – old toys and tins, drawings, photographs.

But an altarpiece as format? Was it Babel's stories:
his juxtaposing of greed and generosity; run-of-the-mill
brutality and beauty? What use a God without knowledge
of such things? But then we're all a Work in Progress.
One crucified Christ should suffice a central panel;

but no, you made it five, adding insult to injury, layer
upon layer, with extra thorns, incisions, blood.
Whose hand inscribed that text? You must have kept it
in a drawer of scraps, along with resurrection words,
to paste across a chosen mouth. That one top right.

You gave those to the Jew to assemble; and the photos
of a priest. What were you telling him? What did he say?
Eleven panels: a fine prime number. You kept the fun ones
for yourself – predella and pilaster. Tins flattened, cut
to fit the frames: that toy engine, a clock (but upside

-down), an olive oil can, a plane over Manhattan; odd
narratives, supporting saints of this and that. And the
carpenter you chose (no cross to make or bear), his task –
a sturdy plinth, a pinnacle of forty-three prime colours.
We stand back, absorb the unorthodox, a visual liturgy.

Collage

Forse hai trovato in Kitaj – quell'outsider del set londinese –
uno spirito gemello nella Pop Art, collage, metodo testuale?
Collaboravi con lui, ma restavi ai comandi:
pensare il concetto, creare il disegno complessivo, selezionare
i significanti – vecchi giocattoli e lattine, disegni, fotografie.

Ma una pala d'altare come format? Era come Babel nei racconti:
sovrapposizione di cupidigia e generosità; ordinarie
brutalità e bellezza? Quale l'uso di un Dio senza la conoscenza
di cose come queste? Ma del resto tutti siamo un Work in Progress.
Un Cristo crocefisso dovrebbe bastare per un pannello centrale;

ma no, tu ne produci cinque, sommando l'insulto alla piaga, strato
sopra strato, con spine supplementari, incisioni, sangue.
Di chi la mano che ha iscritto questo testo? Devi averlo tenuto
in un cassetto di avanzi, insieme a parole di resurrezione,
per incollarle su una bocca prescelta. Quella in alto a destra.

Quelle le hai date a lui, ebreo, da assemblare; e le fotografie
di un prete. Cosa gli dicevi? E lui, cosa diceva lui?
Undici pannelli: un bel numero primo. Quelli buffi li hai tenuti
per te – predella e pilastro. Lattine spianate, ritagliate
per adattarsi alle cornici: quel motore giocattolo, un orologio (ma sotto

-sopra), una tanica d'olio d'oliva, un aereo su Manhattan; strane
narrazioni, che sorreggono santi di questo e quello. E il falegname
che hai scelto (niente croce da fare o portare), suo compito –
un plinto robusto, un pinnacolo di quarantatré colori primari.
Noi, fermi a distanza, assorbiamo la non ortodossia, una liturgia visiva.

FROM HIS FORMATIVE years in his family's confectionary shop just off Leith Walk, to the inner sanctum of his long-established Chelsea studio, Paolozzi stood in the middle of a kaleidoscope of visual imagery. To hand was the full array of images necessary to build his art, from reproductions of classical sculpture and African totems to toy packaging and food container designs. Those who know Paolozzi's art and method also know very well how he puts these elements all together. He is a child of modernist forms – collage, assemblage, bricolage.

Work in Progress harks back to the artists of the classic avant-garde, the constructivists, Dadaists and surrealists whom Paolozzi first studied in books then directly encountered during his first trip to Paris in 1948, a time when European culture was still emerging from the physical and mental ruinations of war. Yet *Work in Progress* comes over a decade later, when the ghosts from those ruins had been largely banished. What we see are the glowing and vibrating fragments of high and low culture, speaking to each other across their squared-off territories.

This is a work by two artists. Paolozzi collaborated with Ronald Brooks Kitaj, who was only a year beyond graduation from the Royal College of Art. Making art jointly with other artists was rare, though he was well skilled in collaborating with top-end print and sculpture technicians, or with curators or filmmakers. Given the stock-in-trade imagery in *Work in Progress*, from Christianity to kitsch, there is an authorial anonymity here. Without prior knowledge, could you tell the hand of which artist is on these fragments?

By the time *Work in Progress* was made, Paolozzi's reputation as a sculptor was established. He was starting to add printmaking to his repertoire, producing his first screen-printed book, *Metafisikal Translations*, in 1962. Here, words and images, new and recycled, float free from grammatical structure; a tactic of resurrection and renewal that was a hallmark of his method and thinking. In that year he also produced a number of aluminium sculptures such as *Imperial War Museum* and *The Twin Towers of the Sphinx – State II*. The front-facing architectural arrangement of these sculptures mirror the altarpiece feel of *Work in Progress*.

RB Kitaj was eight years younger than Paolozzi but was not lacking in life experience after growing up in the USA during the booming 1950s (an upbringing Paolozzi probably envied). After studying art in New York, he travelled around the Americas as a merchant marine and soldier. Then, in 1958, came his move to England, first to Oxford's Ruskin School and in the following year joining the growing band of pop artists centred on the Royal College of Art such as Derek Boshier, Patrick Caulfield, Allen Jones and, closest to him, David Hockney.

Hockney, more than Paolozzi, loved cross-fertilisations between text and imagery but they both shared an obsession with the chaotic and overwhelming nature of contemporary experience. Meanings and associations bump into each other in a deeply surrealist manner. Indeed, two of Kitaj's paintings from 1961, just before he worked with Paolozzi, employ phrases directly lifted from André Breton's First Surrealist Manifesto of 1924 as their titles: Certain Forms of Association Neglected Before and The Disinterested Play of Thought. Scattering the attention of the viewer with the aim of inviting us to intuit new patterns of possible meaning lies at the root of both artists' intention, and certainly shapes the form and content of Work in Progress.

The breadth of Kitaj's interests, from 19th-century politics and philosophy to the front covers of Time magazine, was commented upon by Paolozzi himself. No doubt reflecting their recent collaboration, in an interview with Richard Hamilton in 1964, he said:

I think the American businessman is just as important to him as 19th-century illustrations of Jesus Christ.

This leads us directly to the square shallow box of Work in Progress, which is organised symmetrically around a central panel with two sets of paired 'windows' (in twos and threes) around this centrepiece. The central panel is filled with five upright and two tilted reproductions of a crucified Christ head, sculpted in wood with additional torn, collaged and ink-painted elements. Across one area is pasted a faint hand-written transcription of a story, 'The Road to Broody' by Isaac Babel (perhaps Work in Progress is imagined as a Tower of Babel). Equally faintly written across one of the Christ heads are the words, 'I indeed am going, but thou shalt tarry till I come' – a phrase linked to Jesus' audience with Pontius Pilate, as set out in The Wandering Jew. Here we must imagine Kitaj asserting his own ancestry into the visual narratives of the piece.

In the smaller portrait and landscape windows, is another photo montage of a seated man from different viewpoints, parts of an Italian olive oil can (with its various quality awards still visible) nailed flat to the work's surface, a montage of the New York skyline below an American Airlines plane, an upturned and handless clock face, and finally, various configurations of abstract and decorative robotic toy components. This almost folk-art assemblage is contained in a frame made by a carpenter to Paolozzi's instructions.

The museum records tell us that the areas created by Kitaj are the large central panel and the small portrait arrangement in the top right, using visual material supplied by Paolozzi. Yet Kitaj seemed to have taken ownership of the work promptly as it was included at his first one-man exhibition at Marlborough Fine Art, London in 1963,

and was sold for £1,000 to the collector of surrealism, Gabrielle Keiller. (Later, this work was part of a major art donation from Keiller to the National Galleries of Scotland.) Paolozzi and Kitaj collaborated on another subsequently destroyed work, which presumably also featured in Kitaj's exhibition.

Work in Progress is a classic piece of surrealist-inspired Pop Art. As renowned critic Lucy Lippard wrote:

> The study of pop culture, growing out of Paolozzi's spontaneous enjoyment of it, is to aid in the fabrication of 'idols or gods'. Thus, a traditional role of the sculptor, the forging of divine or heroic figures, is not abandoned; rather the base of references has been widened. Kitaj, like Paolozzi, has a comparable sense of popular culture...[1]

In this multi-evocative artwork, the pair offer no one clear message beneath the surface. No rational reading is possible, or desired.

Work in Progress anticipates Paolozzi's great screen-print period, replete with boxes jam-packed with iconic imagery, such as *Jesus Colour by Numbers* and *An Empire of Silly Statistics... A Fake War for Public Relations*, both part of the *General Dynamic F.U.N.* series (1965–70). Paolozzi and Kitaj share a love of multiple interpretations, dislocations and telling juxtapositions in arrays of the unexpected. Yet the latter's interest is generally acknowledged to be more literary and from an art historical perspective. The art historian Aby Warburg was greatly admired by Kitaj; the artist describing the writer as:

> like a Surrealist: he tried to bring odd things together like Breton did: 'Magic and logic flowering on the same tree.'[2]

In this work, we might say, magic and logic flower on the same altar.

Andrew Patrizio

1 Lucy Lippard, *Pop Art*, 2014 London: Thames & Hudson (p.60).
2 RB Kitaj, in Marco Livingstone, 'Iconology as Theme in the Early Work of RB Kitaj', *The Burlington Magazine* 122:928 Jul. 1980 (p.488).

Tottenham Court Road Tube Station
Mosaic Arch Fragments

" The Tottenham Court Road Mosaic was (indirectly) the reason that my family and I moved to Bristol, and Ray moved to Newhaven. My brother's bedroom was also his incredibly cluttered workroom; it was a large room, but it had its limits. A model of Tottenham Court Road was the catalyst. There was no table space available for the model, so Ray's bed was converted into an extra surface – and he slept on the floor. This made him understandably cross and tetchy, and he broke a lot of plates every time he washed up. The time had come to move... "

Tottenham Court Road Tube Station Mosaic Arch Fragments, EU3960

DATE: 1983

MEDIUM: Mosaic (a selection from 768 fragments)

DIMENSIONS: Various sizes

PROVENANCE: Gifted to the University of Edinburgh by Transport for London

LOCATION: University of Edinburgh Art Collection

Photography by University of Edinburgh Digital Imaging Unit

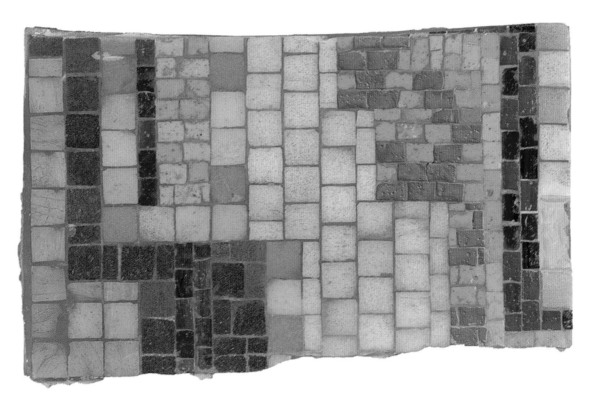

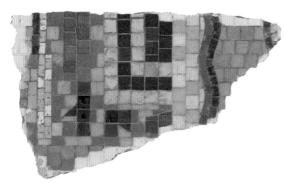

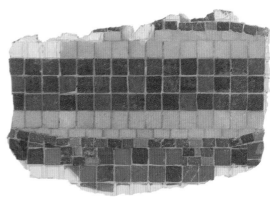

Making all things new

This was my masterpiece, street story, work story:
I was only ever two steps away from one or other,
in thrall to both. I would write it, my mosaic,
to enrich and brighten the lives of passengers
on the Northern Line, on the Central Line
as they tumbled from Tottenham Court Road,
shoved and jostled, hurtled down escalators.

Old glass – Italian of course. Run your eye
over the pieces; run your fingers over them.
So many pigments: no two tiles identical.
And texture, light, a myriad of subtle shades.
Brilliant, permanent and scrubbable colour:
that's what they are, what they give us.
They gleam, obliterate our darker places,

run along the track, arch overhead, fly
in the face of all that is dull and dismal.
There were years of cutting, shaping, fixing,
bringing my design to life. I raise my glass
to the mosaicist – one of a long line of makers
whose work now lies in dust and rubble.
How do we weigh art against convenience?

Four unboxed jigsaws: that's what you've got.
It's fitting that the Infomatics folk can pit their wits,
share their forensic skills on how it fits together.
Re-shape the scraps you salvaged as you wish;
I am all for re-making. Turn barbarism on its head.
I am content to be the new Colourist for the city.
Edinburgh, I embrace your early and your late love.

Rifare tutto di nuovo

Questo è stato il mio capolavoro, storia di strada, storia di lavoro:
ero sempre a distanza di non più di due passi dall'una e dall'altra,
in balia di entrambe. Volevo scriverlo, questo mio mosaico,
per arricchire e fare più allegra la vita dei passeggeri
della Linea Nord, della Linea Centrale
mentre si rovesciano da Tottenham Court Road
si spingono e si urtano, scendono di corsa lungo le scale mobili.

Vecchio vetro – italiano naturalmente. Fai scorrere gli occhi
sui pezzi: fai scorrere le dita sopra ognuno dei pezzi.
Sono tanti i pigmenti: non due tessere identiche.
E la testura, luminosa, una miriade di sfumature sottili.
Colore brillante, permanente e lavabile:
ecco quello che sono, e quello che donano a noi.
Scintillano, obliterano i nostri luoghi più oscuri,

corrono lungo il percorso, si inarcano in alto, volano
in faccia a tutto quello che è opaco e squallido.
Ci sono voluti anni per tagliare, configurare, fissare,
dare la vita al mio disegno. Io levo il calice
al mosaicista – uno di una lunga schiera di artefici
il cui lavoro ora giace in polvere e pezzi rotti.
Che peso diamo all'arte nella gara con la funzionalità?

Quattro rompicapi fuori confezione: questo quello che avete.
Sembra una cosa giusta che gli informatici si confrontino,
mettano insieme competenze forensiche su come ricomporli.
Ri-date forma come desiderate ai frantumi che avete salvato;
Sono del tutto d'accordo per ri-farlo. Capovolgete la barbarie.
Sono contento di essere il nuovo Colorista della città.
Edimburgo, abbraccio il tuo precoce e il tuo recente amore.

IN AUTUMN 2015, the remains of Tottenham Court Road Tube Station's mosaic arches arrived at Edinburgh College of Art (ECA). Unloaded and laid out in the Sculpture Court, staff from the University's Art Collection began cataloguing material that had sat for over 30 years, deep under Oxford Street. The 650 or so mosaic fragments were like dusty, alien arrivals in Edinburgh, far from their original home.

Relocated to Scotland, the fragments manifest their journey: the concrete and mortar reveal the layers of their creation; their vibrant colours and patterns express the abstract designs for which they were admired; the dust and cracks tell of how they were dismantled. Their future, like their fragmented state, is a puzzle...

In February 1980, artist Eduardo Paolozzi submitted artistic designs for Tottenham Court Road Tube Station to London Regional Transport.[1] Around that time the organisation, now more familiar to us as Transport for London (TfL), was embarking on a redevelopment project for London Underground's Central Line, a modernisation of all the stations served by that service. With this important work came an opportunity to involve artists and incorporate site-specific artworks in the refurbished stations; Paolozzi was one of the invitees.

Over the next five years, Paolozzi worked with mosaicists and architects to achieve his colourful vision for Tottenham Court Road; in the end his 955 square metres of mosaic design gave the station, as art historian Richard Cork asserted, 'an irrepressible new identity'.[2] Dynamic images, inspired by contemporary culture and the locality, filled the station's platforms and corridors. Alongside this, curved over the main escalators were three rows of arches, laden with mosaics. These were a significant component of Paolozzi's iconic commission, a special passageway for commuters and tourists getting to and from their trains. In total the arches had four designs: the first and second designs have been interpreted as representing 'behind the scenes', drains and pipes or watch straps, a nod to tube users checking the time as they travelled. The third and fourth designs were inspired by various recurring Paolozzi motifs and parts of an Egyptian panel in the nearby British Museum.

Just over 30 years later, in 2011, TfL announced that the station needed updating for contemporary needs and as part of the Crossrail project. While restorative plans were developed for the mosaics on the platforms and the iconic rotunda, the arches were to be removed from the station. Agreeing with contractors and structural engineers that they could be neither retained nor removed undamaged, the Paolozzi Foundation accepted that the arches were to be dismantled and no longer featured in the station. This potential loss sparked much

1 Cork, R (ed), *Eduardo Paolozzi Underground*, Exhibition Catalogue, Royal Academy of the Arts with Weidenfeld and Nicolson, London 1986.

2 Ibid.

protest when announced publicly. Championed by 20th Century Society, a campaign formed to save them and the arches' story garnered media coverage. Despite this, in January 2015, the arches were removed, never to return to the station. But the campaign had given the arches a future; with their artistic value highlighted, TfL were obliged to find them a new home. Given Paolozzi's links to the city, ECA and The Art Collection, the University of Edinburgh seemed the appropriate place for such a gift.

Although it was highly likely that not all the material had survived the removal, it was not clear how much was actually lost. This uncertainty determined the University's next steps for the fragments: a collaboration with the School of Informatics. Led by the Chair in Computer Vision, Professor Bob Fisher, and PhD student Alex Davies, this collaboration set out to digitally map each fragment against the original designs using image recognition software called MATLAB. A photograph of each fragment was scanned into this program and a matched location was generated. While this provided vital knowledge regarding the fragment location, it also complicated plans for their redisplay with the discovery that tragically only 33 per cent of the arches had been saved.

In November 2016, a couple of months after this discovery, another of Paolozzi's London sculptures hit the headlines; *Picastor*, an enormous abstracted head made of bronze located outside Euston Station, was in a vulnerable state. Due to the ambiguity of its ownership, it was neglected and showed signs of being under-maintained.[3] Both *Picastor* and the arches highlight the precarious life of an artwork in the public realm. Even though it might be made of a resilient material or embedded into a building's structure, the care and permanent display of art is not a guarantee. It must be fought for, as decisions to conserve and protect are complicated and at the mercy of strained resources. In comparison to *Picastor*, the mosaic arches, broken up with missing parts, perhaps seem defeated.

However, in coming to the university, The Art Collection got a rare opportunity to explore the aftermath of the mosaics' destruction, to search for a future that did not involve condemning the fragments to gather dust in storage. But if not that, then what? How should the mosaic fragments be used, viewed or assembled? As an arch? Should their display tragically emphasise the missing parts and loss of context like the Parthenon marbles in the British Museum? Or was there another option?

After using them in teaching and as part of talks and conferences, in the end an answer came (perhaps not too surprisingly) from Paolozzi himself. Playing with recycling, reconfiguring and the collage of material, Paolozzi explored what he referred to as 'the metamorpho-

3 Bowdler, R, 'Paolozzi sculpture at Euston is one of many works of art left to rot', *The Guardian*, 29 November 2016.

sis of rubbish'.[4] At his work's core was a 'relish for experimentation, for readjustment, re-examination',[5] a desire that any university shares with Paolozzi. And so, in keeping with this spirit, the unfinishable puzzle can be transformed and celebrated anew.

Liv Laumenech

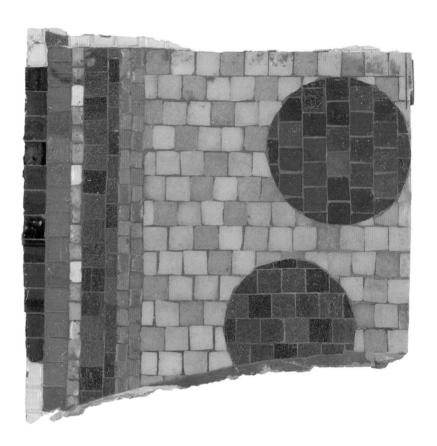

4 'Metamorphosis of Rubbish', *The Times*, 2 May 1958 (p.7).

5 Eduardo Paolozzi: Sculptures for the King's Buildings, Faculty of Science and Engineering and Institute of Cell and Molecular Biology, University of Edinburgh, 1997.

Master of the Universe

“ This is Newton, but also Eduardo; the head is unmistakably that of the sculptor. It was Ray who told me that, whereas the Newton at SNG Modern Two is blind, the Newton at the British Library was given the eyes of Michelangelo's David. (Why? I don't know. I wish I did.) The sculpture was created by cutting up and reassembling a plaster model; much of Eduardo's later works were made this way. Both his Dovehouse Street studio and Ray's room were incredibly dusty; if you moved fast, swirls of plaster dust would eddy round your ankles. ”

Master of the Universe

DATE: 1989

MEDIUM: Bronze

DIMENSIONS: 1.47 m x 1.90 m x 1.07 m

PROVENANCE: Purchased by the National Galleries of Scotland in 1990

LOCATION: Outside Modern Two, Scottish National Gallery of Modern Art, Edinburgh

COPYRIGHT: © Trustees of the Paolozzi Foundation, Licensed by DACS 2017

Collection of the National Galleries of Scotland.

Photography by Antonia Reeve

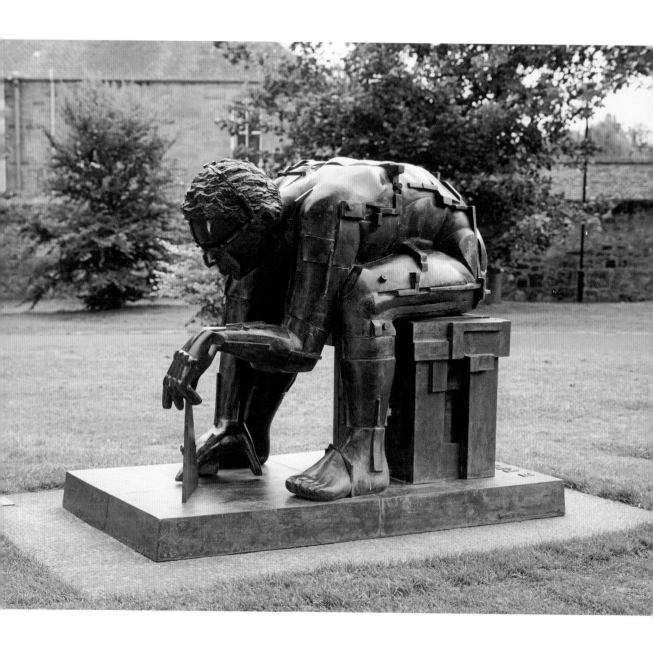

Ocean of truth

*'I do not know what I may appear to the world, but to myself I seem
to have been only like a boy playing on the sea-shore... whilst the
great ocean of truth lay all undiscovered before me.'**

This sculpture began with Blake's image of Newton,
a God-like figure – in ink and watercolour – hunched
naked over a measureable world. Blake recognised
the gifted analytic mind but thought there was
a hidden darkness in Newton: that he was blind
to beauty in creation; to splendour that lights up
the laws of physics, that can outweigh pure reason.
In his view God's compasses had been constrained.

But Newton was no scientist of single vision;
he merely tried to comprehend the underpinnings.
This father of Physics set out in mathematics
the laws of motion that held the heavens, made
sense of falling, rotating, accelerating, colliding;
abstracted equations for the calculus of curves;
determined the nature of colour and of light.
He pulled it all together, saw the striking patterns.

Paolozzi surely captured Newton's brilliance. You'd
swear he'd given him a pair of spectacles, maybe
to help him see more clearly. Our Scottish sculpture
of the physicist is smaller; joints and bolts re-thinking
links between mechanical and imaginative worlds.
It's placed outside a gallery of art rather than a library –
perhaps he's pondering all beautiful things, some
which escape equations; a startling, integrated truth.

* *Memoirs of the Life, Writings, and Discoveries of Sir Isaac Newton* (1855)
 by Sir David Brewster (Volume II. Ch. 27).

Oceano di verità

Questa scultura ebbe inizio con Newton immaginato da Blake,
una figura simile a Dio – in inchiostro e acquerello – inarcato
e nudo su un mondo misurabile. Blake aveva riconosciuto
i doni di quella mente analitica, ma pensava che esistesse
in Newton un'oscurità nascosta: che Newton fosse cieco davanti
alla bellezza della creazione; allo splendore che accende di luce
le leggi della fisica, che può avere più peso della pura ragione.
Nella sua visione, ai compassi di Dio erano stati imposti limiti.

Ma Newton non era scienziato da una singola visione;
lui si sforzava solo di comprendere cosa sosteneva il tutto.
Questo padre della Fisica ha esposto in forma matematica
le leggi del moto che tenevano insieme i cieli, ha dato
un senso logico al cadere, ruotare, accelerare, collidere;
ha ricavato le equazioni per il calcolo delle curve;
ha determinato la natura del colore e della luce.
Ha messo insieme il tutto, e visto gli strabilianti disegni.

Paolozzi ha colto la mente brillante di Newton. Giureresti
che gli abbia dato un paio di occhiali perché forse voleva
aiutarlo a vedere più chiaramente. La nostra scultura scozzese
del grande fisico è più piccola; giunzioni e bulloni ri-pensano
i legami tra i mondi della meccanica e della immaginazione.
È posta davanti a una galleria d'arte invece che in una biblioteca –
Forse Newton sta ponderando tutte le cose belle,
che sfuggono alle equazioni: una sbalorditiva verità integrata.

As Newton numbered the stars, and as Linnaeus numbered the plants, so Chaucer numbered the classes of men.

William Blake, A Descriptive Catalogue, 1809

JAMES JOYCE CLAIMED that Dublin on 16 June 1904 could be fully replicated from the portrayal of 'Bloomsday' in his novel *Ulysses*.[1] A similar claim, but on a much more epic scale, was lodged by the science fiction writer, JG Ballard,[2] a long-time admirer of the artist, who proffered the seemingly outrageous notion that if the whole of 20th century civilisation was wiped out, later archaeologists would be able to reconstruct it from all the information contained in the vast work of Eduardo Paolozzi. Whether this piece of supreme hyperbole has any justification to it is of course open to debate, but the artist does appear to portray himself in this late sculpture, as the master creator of all things.

Such claims are by nature metaphorical, and it was through the imaginative and creative use of metaphor – and its visual equivalent collage – that Joyce, and later Paolozzi, radically developed fresh languages of representation. They used them to describe and critically scrutinise the multi-faceted aspects and complex workings of our brave new modern world. These innovative textual and visual languages, with their endless permutations of equivalents, allowed Paolozzi, for instance, to formulate an encyclopaedic lexicon of new forms and highly flexible syntax, endowing the artist with the imaginative intellectual power to build and evolve his own vision and version of contemporary reality. Thus everything that grew out of, walked on, or flew over the earth's surface could now be re-shaped and re-presented in different forms through the artist's awesome creative power of metamorphosis. Like a modern-day Linnaeus or Chaucer, Paolozzi could number the plants in his own botanical empire; and list the different types of creatures, men and deities in his animal and human kingdom – from insects, reptiles and mutants, to monsters, heroes and gods. He could even match Newton, not with astronomical stars, but with cinematic ones which, as the Hollywood studio MGM claimed, even outnumbered the heavenly constellations.

The *Master of the Universe* is the evolutionary apotheosis of Paolozzi's self-created chain of being which began with his early brutish creatures and figures of the 1950s. These he cobbled together from the debris and detritus left behind after the destructive waste of the preceding war years. These inchoate figures tottering on their shaky spindly legs still possess a raw energy and primitive aura to them as though they have just emerged from the primordial swamp and are attempting to stand upright and walk forward into human history. By the 1960s, Paolozzi's figures had evolved into beings of a

1 *James Joyce and the Making of Ulysses,* Indiana UP, 1960.
2 *Extreme Metaphors – Interviews with JG Ballard 1967–2008,* Harper Collins 2012.

very different character. Still using his favoured, highly adaptable collage approach, he now drew his source material from factory mass-produced units which were re-arranged into different permutations to give his latest state-of-the-art figures a much more hard-edged abstract appearance. Furthermore, in tune with the mood of the 'swinging sixties' and the Pop Art era, Paolozzi also emblazoned much of his sculpture of that time with bright jazzy colours.

After his controversial 1971 retrospective exhibition at the Tate Gallery, Paolozzi produced relatively little figurative sculpture for the next decade or so. But by the end of the 1980s, he had returned to the figure with greatly increased enthusiastic energy and a new attitude and approach. He now envisaged his sculptural creations as being figures of notable public status and culturally important within the noble, classical tradition. Appropriately, many of these sculptures were commissioned to be placed in important civic sites, the most famous being his *Newton*, prominently raised and situated outside the British Library in 1997. Paolozzi's method for the creation of these late figures was again an innovative variation on his collage sculptural technique. Following the example of Rodin, whom he admired greatly, Paolozzi began building up an enormous store of plaster figures cast from a variety of high and popular cultural sources, from Michelangelo's *David* to Walt Disney's *Mickey Mouse*. These plaster figures then could be pulled out whenever needed in order to be cut into different anatomical sections. The fragmented bodily pieces could subsequently be rearranged and reconstructed to supply an endless variety of reassembled figure compositions in a Frankenstein manner.

Master of the Universe comes out of such a complex and protracted process. It began with Paolozzi's long-standing fascination with William Blake's famous satirical print of the great scientist, Isaac Newton. Blake depicts him as naked, sitting on a rock under the sea of materialism and bent over a scroll over which he holds, as his mathematical attribute, a pair of compasses. Paolozzi admired what he saw as the duality in Blake's image 'presenting to us simultaneously nature and science – welded, interconnecting, interdependent',[3] significantly, the same notable characteristics and concerns of Paolozzi's own art. He initially translated Blake's *Newton* into a plaster relief of a highly mechanised figure, from which developed his subsequent series of small scale plaster and bronze maquettes. For the later public commissioned versions of this work, Paolozzi greatly enlarged the figure, giving it a more muscular physique while still retaining elements of its mechanised form through its plated and bolted surface. He also introduced a self-portrait head to the figure. There are, however, subtle differences between the various versions. For example, whereas *Newton* of the British Library has eyes like

3 Eduardo Paolozzi lecture in the Contemporary Arts Society, 1988.

Michelangelo's *David* and wields a giant pair of compasses, *Master of the Universe* is eyeless and holds a flat triangle in his hand. The statue is situated near the garden entrance to the grounds of the Scottish National Gallery of Modern Art's, Modern Two. Appropriately it is in close proximity to a sculpture by Paolozzi's early studio partner and former Independent Group associate, William Turnbull, entitled *Gate* (1972). Turnbull's work, with its shiny, burnished, stainless steel surface and its open, geometric, minimalist, highly abstracted composition makes a striking contrast to Paolozzi's *Master of the Universe*.

In the 1950s when Paolozzi was still experimenting with different ways to develop his art, he observed that 'a plastic iconography is as difficult as a language'.[4] Four decades on, in the 1990s, Paolozzi had mastered those difficulties and could draw upon an infinite range of sources to give undoubted authority and substance to his work.

> My own readings or source material is largely that of previous art works, technical magazines and books, a world of intricate problems and a lucid language.[5]

Master of the Universe is a superb example of this. The protean figure carries within it a history of Western figurative art from Hellenistic/ Roman, idealised bodies with portrait heads, to the medieval image of *God the Geometer*, to Michelangelo's figure of Abias on the Sistine ceiling, to Blake's *Newton*, to Rodin's *Thinker*, to Frankenstein's monster and through to a comic strip, Nietzschean Superman.

Finally with that Nietzschean concept in mind, it is interesting to compare the attitudes of James Joyce and Eduardo Paolozzi to the issue of the master artist/creator. While Joyce stated:

> The artist, like the God of Creation, remains... above his handiwork, invisible, refined out of existence, indifferent, paring his fingernails[6]

Paolozzi did not assume such an aloof and detached attitude to his own universe.

> I'm interested in the total idea of being an artist. I like the possibility of perhaps working on several levels, and I like the idea of a challenge.[7]

Thus the *Master of the Universe* is never fully satisfied with his handiwork, but forever looking to create and bring into being yet more brave new worlds.

Bill Hare

4 Eduardo Paolozzi lecture at the Institute of Contemporary Arts, 1958.

5 Michael Middleton, *Eduardo Paolozzi*, London 1963.

6 James Joyce, *A Portrait of the Artist as a Young Man*, Chapter 5.

7 Judith Collins, *Eduardo Paolozzi*, 2014.

Paolozzi Maquettes

" From where I am in my sitting room, I can see seven maquettes. No, nine. They were all made by Ray; the process was very simple – plaster was poured into a red rubber mould, and left to set hard. The moulds were made of something that Ray called 'Wubbastuff' (I don't know if this is the correct name, but when hot and liquid it smelt revolting). "

Maquettes

Crickets Mating (Large), EU1161; Engine, EU1170
Medium Romanesque Foot, EU1207; Frog, EU1179

DATE: Various

MEDIUM: Plaster

DIMENSIONS: Crickets Mating (Large) 9 x 25 x 5 cm
Engine 7x2x9 cm; Medium Romanesque Foot 11 x 18 x 9 cm

PROVENANCE: Included in bequest from artist's estate in 2007

LOCATION: University of Edinburgh Art Collection

The University of Edinburgh Art Collection

COPYRIGHT: © Jonathan Clark Fine Art, Representatives of the Artist's Estate

Photography by University of Edinburgh Digital Imaging Unit

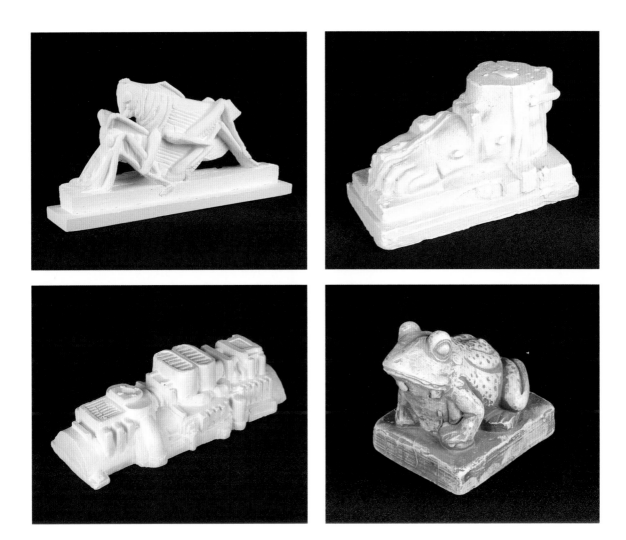

Thinking ahead

Viewing Paolozzi maquettes
24 June 2016 – the results of Brexit referendum

The result is sinking in – we've decided
as a nation to cut our continental ties,
retreat into our island-ness. What a day
to be viewing Paolozzi's work: a man with
a talent – pan-European in scope – too big
for one country to claim or to contain.

His maquettes are works in progress, like we are,
like most things are. But his are prototypes
for something bigger, greater. Some are moulded,
some are plaster worked with rag and hand.
Various body parts – a head, a foot – are cut,
re-formed; technologically transformed,

while some display unmediated vision.
A machine metaphor might have worked for
Turing's head but this maquette is subtle, artless:
hair smudged by the sculptor's hand; almost
a tender gesture of comfort, of respect;
a mark of our precarious humanity.

The pieces are boxed and labelled and, like
the Chinese Warriors, too much to take in;
too many for one life, one artist's dream.
The hand is beautiful, an unexpected blessing;
the frog, a knot of gulping energy, set to leap;
the engine, a child's delight in detail, revving.

It seems he saw what lay beneath the skin,
that huge concepts can lurk in little works of art;
that while we have a chance for change, before
we say goodbye – while things are malleable – then
modelling results is more than valuable, before
they're set in stone or bronze, before the ink is dry.

Il pensiero che anticipa

Visita alle maquettes di Eduardo Paolozzi
24 giugno 2016 – i risultati del referendum sulla Brexit

Il risultato sta penetrando a fondo – abbiamo deciso
come nazione di recidere i nostri legami continentali,
ritirarci nella nostra insularità. Che giorno questo
per visitare l'opera di Paolozzi: uomo dotato di
un talento – di portata pan-europea – troppo grande
per una nazione sola da attribuirsi e contenere.

Le sue maquettes sono *work in progress*, come siamo noi,
come molte cose sono. Ma i suoi bozzetti sono prototipi
di qualcosa di più grande, più formidabile. Alcuni sono fusi,
alcuni sono gesso lavorato con mano e straccio.
Varie parti del corpo – una testa, un piede – sono tagliate,
ri-formate; tecnologicamente trasformate,

mentre alcuni mostrano non-meditata visione.
Una macchina poteva funzionare come metafora per
la testa di Alan Turing, ma la maquette è sottile, naturale:
i capelli tracciati dalla mano dello scultore; quasi un gesto
di tenerezza, di conforto, di rispetto;
un segno della nostra precaria umanità.

I pezzi sono etichettati e inscatolati e, come
i Guerrieri Cinesi, sono troppo da assimilare;
troppi per una sola vita, il sogno di un solo artista.
La mano è bellissima, una inattesa benedizione;
la rana, un nodo di energia in pressione, pronta a saltare;
il motore una gioia infantile nel dettaglio, trascinante.

Sembra che lui potesse vedere cosa stava sotto la pelle,
che grandi concetti possono celarsi in piccoli oggetti d'arte;
che finché abbiamo una chance di cambiare, prima
di dire addio – finché le cose sono malleabili – allora
creare modelli dei risultati ha più che un valore, prima che
siano fissi in pietra o bronzo, prima che sia secco l'inchiostro.

PAOLOZZI'S WORKS ARE hard to ignore. When you visit the British Library, you are greeted by the hunched-over figure of *Newton* (1995) absorbed in research, mimicking the many researchers in the Library. If you visit the Modern Two building at the Scottish National Gallery of Modern Art for afternoon tea, you run the risk of being trampled on by Paolozzi's imposing work, *Vulcan* (1998–1999).

Paolozzi's finished works are often large and impactful, but the creation of these works started on a much smaller scale, through his maquettes and models.

Firstly, let's have a look at his maquettes. A maquette is a crucial stage in the development of 3D or sculptural work. It allows an artist to experiment with ideas on a smaller scale and with cheaper material such as plaster, clay, wood and wax before picking the best maquette for casting, creating a final work which may be larger in size and made with more expensive materials such as bronze.

Maquettes were an important part in the development of Paolozzi's work. He would first sketch his plan for a large scale work or sculpture on paper, create numerous models made out of plaster to experiment with and develop his idea. He would then create a number of maquettes and pick the best one to be cast and scaled up for his final work. You can see an example of this when you visit Paolozzi's Studio at Modern Two. If you look at the shelves on your right, you will see rows and rows of plaster casts of locusts. These locusts were part of the development of *The Manuscript of Monte Cassino* (1991), with Paolozzi experimenting with numerous models and using one of them as a maquette to create the two locusts on the hand of the finished sculpture.

It wasn't just his sculptures for which Paolozzi created maquettes. A collection of maquettes held at the National Galleries of Scotland includes models of his plans for the Tottenham Court Road Underground Station. These maquettes, created between 1980 and 1981, are made of plywood, hardboard, collaged paper, paint and pen and show his mosaic plans, in a scaled down model of Tottenham Court Road. They are, again, an excellent insight into the working mind of Paolozzi and the development of his work.

Alongside these maquettes of finished works, Paolozzi created hundreds, if not thousands, of other models made out of plaster to help develop his ideas. He would create plaster casts of anything and everything. He regularly frequented markets and sought out skips where he would pick up items such as keys, engine parts, toys and games to create casts of these items. Paolozzi mentioned his process of creating plaster cast models in a lecture given at the Institute of Contemporary Arts, 1958:

> Here is a list of objects which are used in my work, that is to say, pressed into a slab of clay in different formations. This forms an exact

impression (in the negative of course) and from this a store of design sheets can be built up. They range from extremely mechanical shapes to resembling pieces of bark.[1]

Once the objects created an impression on the clay he would then either pour plaster or wax into the space left behind in the clay to create a positive form to work with. Paolozzi was a person who lamented plaster work not being appreciated as a work of art in itself. Paolozzi scholar Robin Spencer noted:

> He was very keen that the medium of plaster should have a higher status as a sculptural medium that it had previously enjoyed in the 20th century. He took particular interest in this question after Albert Elsen's *Rodin Rediscovered* exhibition (1981) which re-valued Rodin's practice with plaster.[2]

Paolozzi's models and maquettes represent a stage in the development of his work from sketch to model to maquette to sculpture. He explained this in an interview with Edouard Roditi (1910–1992) first published as 'The Artist Sketches an Aesthetic of the *Objet Trouvé* Based on a Conscious Metamorphosis of the Derelict', *Arts* (New York, May 1959):

> I am interested, above all, in investigating the golden ability of the artist to achieve a metamorphosis of quite ordinary things into something wonderful and extraordinary that is neither nonsensical nor morally edifying[3]

Paolozzi continued:

> I first build up my model by cementing my salvaged *objets trouvés* together with clay, after which I make, with my assistant, a plaster cast of them, and in this cast a wax mould that is finally sent to be cast in bronze. This is what imposes, in addition to a formal metamorphosis, a material metamorphosis on all my materials.[4]

As you look around Modern Two you can be struck by the number of the casts of shoes, cars, locusts, heads, guns, frogs, mice with threaded whiskers, etc. You may start to wonder why he created and kept so many of them. Paolozzi did not like anything going to waste and was always acutely aware that he could use repeated motifs in his work. If, for example, you look at his sculptural work *Tyrannical Tower Crowned with Thorns of Violence* (1961) you can see the imprints on the bronze where he has placed mechanical items which he had collected to use in his work.

Although many of them are small in stature, Paolozzi's models and maquettes show us the steps Paolozzi took from sketch to model to maquette to a completed sculpture. For every large scale work you see, you can almost guarantee that somewhere there will be a small plaster version, which Paolozzi shaped and worked on, that you can fit in your hand.

Fiona Menzies

1 Robin Spencer (ed.), *Eduardo Paolozzi, Writings and Interviews*, Oxford University Press, 2000 (p.81).

2 Robin Spencer – www.jameshymangallery.com/art-exhibitions-archive/1017/press/eduardo-paolozzi-forty-plasters.

3 Robin Spencer (ed), *Eduardo Paolozzi, Writings and Interviews*, Oxford University Press, 2000 (p.88).

4 Ibid. (p.90).

The Manuscript of Monte Cassino

> **“** I don't know who or what inspired the hand; it could be Eduardo's own. There were numerous possibilities for the foot; visiting Ray in Newhaven, I always saw numerous plaster casts of single feet. One was cast from the foot of an obliging neighbour, and another was Ray's own. They came in all sizes; once when I came I noticed that one was broken. I asked if this was a disaster, but Ray said no. It had been rejected as too refined. **”**

The Manuscript of Monte Cassino

DATE: 1991

MEDIUM: Bronze

DIMENSIONS: Foot: 2.89m x 5.32m x 2.46m; Hand: 1.15m x 4.50m x 2.53m; Ankle: 1.84m x 1.90m x 1.50m

PROVENANCE: Gifted by Sir Tom Farmer to the City of Edinburgh Council

LOCATION: Sited outside St Mary's Metropolitan Cathedral, but currently located at Hillside Crescent Gardens

City of Edinburgh Council.

Photography © Luigi Giannetti (p.53, 54) Luath (p.55)

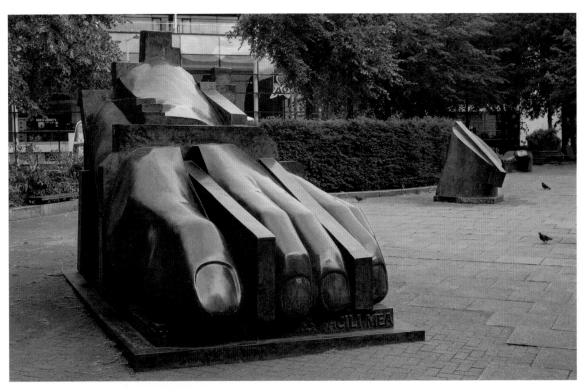

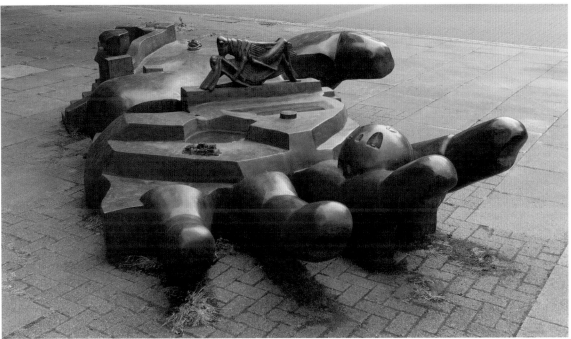

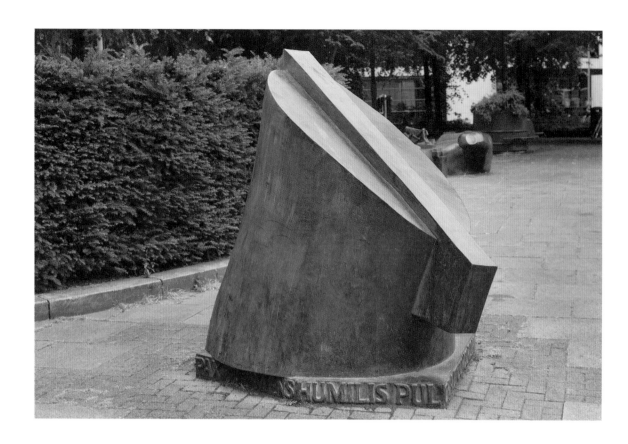

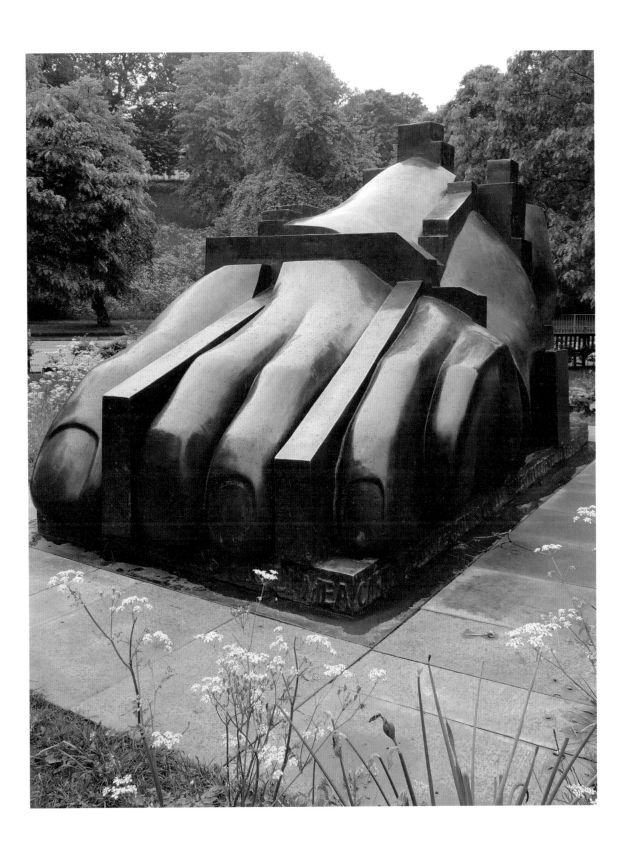

The Manuscript of Monte Cassino

Monte Cassino still conjures up conflicting thoughts
but this is the Manuscript, the tattered fragments:
good, reconciling words picked from the rubble of battle.
Read them slowly: *mea carta, volatu per silvas, colles, valles...*
quoque præpete cursu... as, fleet of foot, you traverse
the woods, hills and valleys... *cari Benedicti tecta require...*
seek out the roof, the shelter of Benedict. But this sculpture
is not a war memorial: it includes joy and celebration.

The huge palm is open, holding symbols of war and peace:
the ball could be ammunition or, like that toy engine,
something benign or playful; more in harmony with nature,
with the copulating crickets, a sign of fertility; or the lizard
with the broken tail that shows courage in the face of danger,
rescues himself by letting go. He leaves the past behind,
risks all for another chance. Children can play
in the bounty of placid pools. The steps are child-sized.

The mighty foot rises as villages above Frosinone's valleys,
as Viticuso rises, block by block, on its ancient stump.
It has walked with those who trudged out of that poverty;
it walks with those who still leave home and hearth; who,
like the lizard, hazard this life for something better.
It has buried soldiers dead on either side of battle, has seen
internment, been sunk at sea, come up the aisle to receive
the eucharist, has stood behind the counter, struggled.

Each sculpted toe has the magnificence of the shattered foot
of Constantine. The pieces of the body lie scattered,
it is for us to bring them together, re-imagine wholeness.
It lies between St Mary's – home to a city's Italians – and
Leith where many settled. The pieces of life's jigsaws:
pax pia, mens humilis, pulchra et concordia fratrum,
laus, amor et cultus Christi... among the brethren there is
consecrated peace, humility and concord; praise, love
and worship of Christ... The art says it all. So be it.

Il Manoscritto di Monte Cassino

Monte Cassino evoca ancora pensieri conflittuali,
ma questo è il Manoscritto, i frammenti lacerati:
parole buone, riconciliate, raccolte tra i detriti della battaglia.
Leggete lentamente: *mea carta, volata per silvas, colles, valles...*
quoque praepete cursu... mentre, agile il piede, traversate
i boschi, le colline e le valli... *cari Benedicti tectu require...*
cercate quel tetto, l'ospizio di Benedetto. Ma questa scultura
non è un memoriale di guerra: accoglie gioia e celebrazione.

Il grande palmo aperto, contiene simboli di guerra e di pace:
la palla può essere un proiettile, o, come il motore giocattolo,
qualcosa di benigno o giocoso; più in armonia con la natura,
con l'accoppiamento di grilli, segno di fertilità; o la lucertola
con la coda mozza che in faccia al pericolo mostra il suo coraggio,
si salva cedendo qualcosa. Lascia dietro di sé il passato,
rischia tutto per un'altra occasione. I bambini possono giocare
nel lusso di placide pozze. I gradini sono a loro misura.

Il piede possente si erge come i villaggi sopra le valli di Frosinone,
come Viticuso si erge, edificio su edificio, sulla sua antica rupe.
Ha camminato con coloro che faticando fuggivano quella povertà;
cammina con coloro che lasciano tuttora casa e focolare; coloro che,
come la lucertola, rischiano questa vita per qualcosa di migliore.
Ha seppellito soldati morti, da entrambe le parti della battaglia, visto
internamenti, è affondato in mare, ha risalito la navata per ricevere
l'eucarestia, è stato dietro un bancone, spossato dalla fatica.

Ogni dito del piede ha la magnificenza del piede frantumato
della statua di Costantino. I pezzi del corpo sono sparsi,
a noi spetta rimetterli insieme, ri-immaginarne la interezza.
Si estendono tra la Chiesa di St.Mary – casa per gli italiani – e la città
di Leith dove in molti si sono stabiliti. Pezzi dell'incastro della vita:
pax pia, mens humilis, pulchra et concordia fratrum,
laus, amor et cultus Christi... tra i confratelli vive
la pace consacrata, l'umiltà e la concordia; la lode, l'amore
e il culto di Cristo... L'arte dice tutto questo. E così sia.

PAOLOZZI'S FAMILY comes from Viticuso, the hilly terrain of Lazio, 130 kilometres south-east of Rome in the province of Frosinone. Paolozzi's maternal grandfather Pietro Rossi emigrated to Scotland after 1902 and was followed by his father, Alfonso Rudolfo Paolozzi. After serving in the Italian army, he arrived in Edinburgh in 1920 and married Maria Carmela Rossi in 1922. Eduardo was born two years later at 6 Crown Place at the foot of Leith Walk, next to Leith Central Station. His grandfather, Pietro Rossi, had an ice-cream shop nearby while home was above his father's confectionery and ice cream shop at 12 Albert Street, further up Leith Walk near Pilrig. From the ages of four to 12, Eduardo was a pupil at Leith Walk School, which he liked, and between 12 and 16, he attended Holy Cross Academy, which he hated. As a child he went to the Star of the Sea Catholic Church in Leith, and on Sundays to mass at St Mary's Metropolitan Cathedral.

The massive bronze fragments of an ankle, hand and foot, known as *The Manuscript of Monte Cassino*, was originally situated on Picardy Place outside the cathedral. Paolozzi later wrote:

> The history of the Leith Walk area is firmly united with my autobio-graphy. I worshipped at St Mary's Cathedral, shopped in the stores at the top of [Leith] Walk, dreamed in the local cinema, and played around the Calton Hill columns and the Leith Goods Depot [Leith Central Station].[1]

Paolozzi always referred to his work as the 'translation of experience'. In his 67th year, his boyhood experiences of Leith became the source of inspiration for what he called a 'social sculpture', a term usually associated with the work of Josef Beuys, but here intended as:

> a calm haven of rest within a busy commercial area, a bit of quiet beside an endless stream of pedestrian and vehicular traffic. The sculpture together with trees and landscaping should provide a place to stop or meet on the way to shops, a peninsula from which to view Calton Hill or the rest of the Leith Walk community.[2]

In 1988, Paolozzi's first response to the City of Edinburgh Planning Department's decision to redirect the traffic around Picardy Place, was to design fragments of classical columns in iron or bronze to echo the monument on Calton Hill, which overlooks St Mary's Cathedral and the site of the sculpture. Local granite and recycled paving stones from Leith Central Station (then being demolished), would evoke the vanished shops and cinema.

> A series of metaphors on a human scale – a union of Edinburgh archi-tecture with the natural geology of surrounding hills – a suggestion of abstract geometry and recognisable elements, of ancient memories and shared childhood experiences.[3]

For two years, the precise subject of the sculpture and its arrange-ment were kept open ended and its material, whether iron or bronze,

1 Robin Spencer (ed), *Eduardo Paolozzi: Writings and Interviews*, Oxford University Press, 2000 (p.320).

2 Ibid. (p.320).

3 Robin Spencer (ed), *Eduardo Paolozzi: Writings and Interviews*, Oxford University Press, 2000 (p.320).

undecided. But the initial aim, to complement Edinburgh's historic architecture with a work of appropriate grandeur, remained the same. The final decision to make a giant foot reinterpreted from an ancient sculpture in Rome, the foot of Constantine in the Capitoline Museum, and to specify Monte Cassino in the title, introduced a new narrative and resulted in a sculpture with an entirely different meaning. For the young and for future generations, Monte Cassino will always be history, but for older viewers in 1991 it was still a living memory. Before the Allies' march on Rome, the devastation of Frosinone in the second world war culminated, early in 1944, in the wanton destruction of the Benedictine monastery of Monte Cassino and the death of more than 75,000, only 36 kilometres from Viticuso. Another of his 'social sculptures' made at this time, *For Leonardo* in Munich, had mathematics and geometry as its subject but was also intended for children to climb upon. Paolozzi wrote that it could still:

> focus meaning – a meaning divorced from endless debates and arguments between warring nations and collapsing societies.[4]

In a past age, the innocent victims of a great battle, even a Pyrrhic one like the destruction of Monte Cassino, would have been commemorated in sculpture by an allegorical female figure. In the early years of the last century, the heroic dead might be represented realistically, as Charles Jagger sculpted First World War soldiers on his great bronze and concrete memorial to the Royal Artillery at Hyde Park Corner in London, a work Paolozzi admired. But such conventions to memorialise the past were no longer appropriate for the digital age. For Paolozzi, bland and biomorphic abstractions, often the first resort for public sculpture, were just as unacceptable.

The hand was the first element of the three to be chosen for the Edinburgh sculpture. A cast, entitled *Egypt*, was made for a German museum in 1990, where it was situated outdoors for children to play on. Its mechanistic appearance suggests the hand as a prosthetic extension of the body and the agent of creativity; the DNA ball in its fingers, the origin and continuity of humankind. Embellishing the open hand with a scarab beetle and a pair of reproducing locusts, together with the title *Egypt*, made an unmistakeable reference to the Old Testament's land of milk and honey. 'It invites (as most social sculptures do) human intimacy', Paolozzi said.

The foot and ankle came next. But a foot and ankle are nothing without memory and language to set them on their journey. Inscribed in Latin round the base of the second and third elements of the sculpture is the *Ms of Monte Cassino*, a mediaeval lyric written to Paul the Deacon at Monte Cassino.

4 Ibid. (p.320).

Across the hills and in the valley's shade,
Alone the small script goes,
Seeking for Benedict's beloved roof,
Where waits its sure repose.
They come and find, the tired travellers,
Green herbs and ample bread,
Quiet and brothers' love and humbleness,
Christ's peace on every head.

Translation by Helen Waddell, *Mediaeval Latin Lyrics*, 1929

The verse serves a 'double link', Paolozzi explained:

> Between the Cathedral and the origins of not only my father and
> grandfather but to many Italians who came from these regions to
> make Scotland their home... In the spirit of the text men and women
> will rest in the shadow of the trees, watching their children play on the
> hand, or see, early in the morning, birds take advantage of the pools
> collected on the palm of the hand.

Robin Spencer

The Wealth of Nations

66 This sculpture has always fascinated me, as my brother was undergoing chemotherapy when Eduardo was working on The Wealth of Nations. Eduardo was very concerned; he went to visit Ray a couple of times, and they talked about the process… the tubes (always an attraction for Eduardo) in particular. I've no idea if this was an influence in any way, but I can't help wondering. I don't see the figure as pulling the levers; I see him as hanging on to them, and to me the feet (feet again) look touchingly vulnerable. 99

The Wealth of Nations

DATE: 1992–1993
MEDIUM: Bronze
DIMENSIONS: 4.88 m x 8.54m x 4.58m
PROVENANCE: Commissioned by the Royal Bank of Scotland
LOCATION: Drummond House, Royal Bank of Scotland,
Gyle Business Park, Edinburgh

Royal Bank of Scotland. Photography © Dave Sands

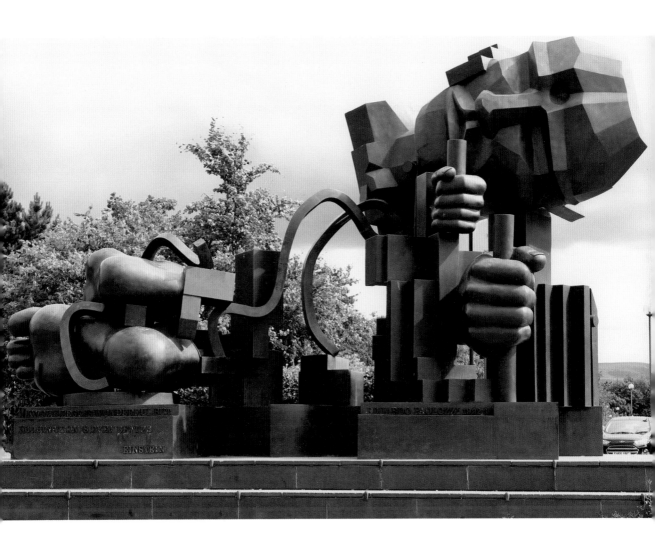

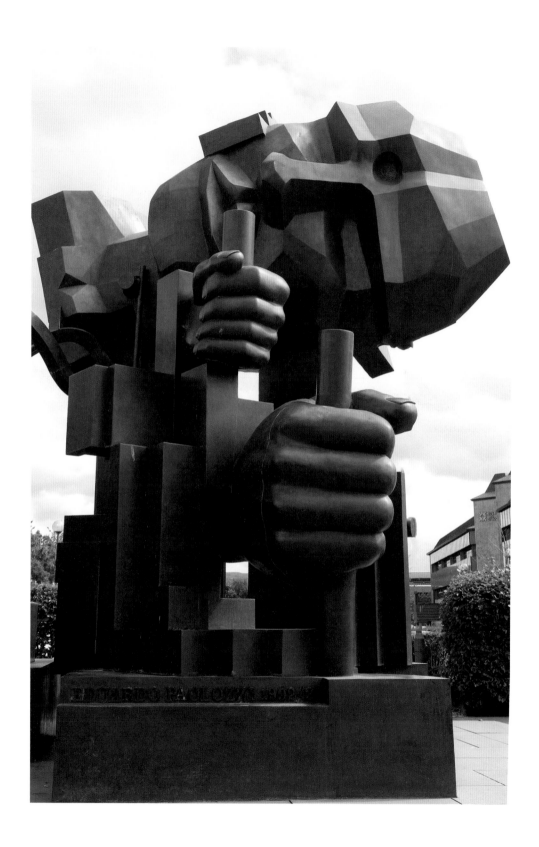

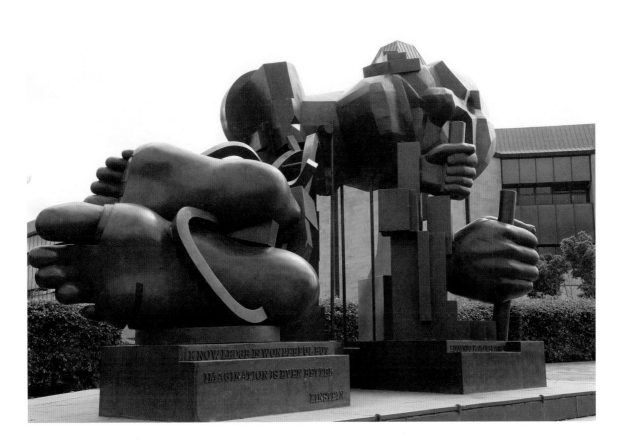

Sum of its parts

It is monumental, more than the sum of its parts:
a man – head and hands – pulling on the levers of
some great endeavour. He embodies concentration.
Lying prone he mines rock, not ledgers; rejects

the spoil; implies that the wealth of nations
accumulates from adding value to the earth's
material gifts through his skill, toil, knowledge,
creativity, technology. From the other side

his head transforms into a piston pump: symbol
of easy wealth, of emptied workplaces checked
from a comfortable distance; of capital as king.
Yet the man persists. He is beyond mere utility.

In this hard-edged world his feet are sensuous,
soft and stoical. They seem to be going in the
other direction. Perhaps, in his imagination,
the man is walking back to another dispensation.

Perhaps he is dreaming of home, of family,
of days without zero hours contracts; of life
beyond relentless cranks and counterweights,
the repetitive turn; beyond digits and ciphers.

Inscription: 'Knowledge is wonderful, imagination is even better.'
Albert Einstein

Somma delle sue parti

È monumentale più della somma delle sue parti:
un uomo – la testa e le mani – che manovra le leve di
qualche grande impresa. Incarna la concentrazione.
In posizione prona estrae roccia, non libri mastri, scarta

le scorie; implica che la ricchezza delle nazioni
si accumula aggiungendo valore ai doni materiali
della terra per mezzo di perizia, fatica, conoscenza,
creatività, tecnologia. Nella parte retrostante

la testa si trasforma in una pompa a pistone: simbolo
della ricchezza facile, di luoghi di lavoro vuoti controllati
a una comoda distanza; del capitale come sovrano.
Tuttavia, l'uomo persiste. Va oltre la pura utilità.

In questo mondo di spigoli duri i suoi piedi sono sensuali,
teneri e stoici. Sembra che stiano andando nell'altra
direzione. Forse, nella sua immaginazione,
l'uomo sta camminando all'indietro verso un'altra mansione.

Forse sta sognando della sua casa, della sua famiglia,
dei giorni senza contratti a zero ore; di una vita
oltre gli ingranaggi implacabili e i contrappesi,
i turni ripetitivi; oltre i numeri e le cifre.

Iscrizione: 'La conoscenza è meravigliosa, l'immaginazione è anche meglio.'
Albert Einstein

EDUARDO PAOLOZZI'S studio, recreated at the Scottish National Gallery of Modern Art, contains a formidable mass of material that evidences the artist's lifelong love of collecting. Among Paolozzi's working models, there are stacks of toys, books and printed ephemera. Lining the walls are shelves crowded with cast elements – row upon row of varying sizes of heads, arms, feet and eyes, jostle for space among assorted abstract forms. Paolozzi's vast collection of elements formed the basis of his working process. In 1965, the artist Richard Hamilton had characterised the artist's working methods as 'Meccano work'.[1] Indeed, toy kits and building blocks are a repeated presence in Paolozzi's collection of popular culture, donated to both the Scottish National Gallery of Modern Art and the Victoria and Albert Museum. In many senses Paolozzi's studio landscape, populated with his immense stock of forms, functioned as the artist's own toy kit. These were elements to which the artist returned tirelessly, playing with new combinations to create his sculptures, prints and public commissions.

The Wealth of Nations is a monumental bronze sculpture that was commissioned from Paolozzi by the Royal Bank of Scotland in 1992. The sculpture was to be placed outside the main entrance of the Royal Bank of Scotland's new administrative offices at Drummond House, Edinburgh. The title of the sculpture is taken from the Scottish economist Adam Smith's seminal work, published in 1776. The sculpture presents dramatically scaled up versions of some of the plaster elements on display in Paolozzi's recreated studio. The reclining figure is formed from head, hands and feet, with a jumble of abstract blocks and curves that take the place of limbs and torso. Retained within the structure of the sculpture is a pronounced connection to the artist's working process, founded on a collection of moveable elements. In fact, Paolozzi's working methods provided problems for the Morris Singer Foundry, tasked with translating Paolozzi's small plaster maquette into the monumental bronze work. According to the foundry, Paolozzi resisted finalising the sculpture, continuing to experiment with different configurations of the elements throughout the scaling up process. This has been interpreted as perfectionism, and although one can certainly see this as a contributing factor, Paolozzi's work also repeatedly seeks ways to challenge the finalisation of the art object. Methods of repetition and recombination exist at the centre of Paolozzi's processes with the artist persistently returning to his 'kit' of forms.

For the philosopher Hans-Georg Gadamer, repetition is central to an understanding of play, defining play as a:

> to-an-fro movement that is not tied to any goal that would bring it to an end; rather, it renews itself in constant repetition.[2]

1 Richard Hamilton as quoted in R Spencer (ed), *Eduardo Paolozzi: Writings and Interviews*, Oxford University Press, 2000 (p.138).
2 H Gadamer, *Truth and Method*, London and New York, Continuum, 2012 (p.104).

Following Gadamer, one can understand Paolozzi's repeated use of a kit of forms, together with his resistance to finalisation, as a play process. Paolozzi's fascination with endless recombination can be seen, in Gadamer's terms, as a 'to-an-fro movement', and despite the fact that Paolozzi worked on public commissions such as *The Wealth of Nations* – a project that existed as a definite 'goal' – the artist sought ways to unsettle the constituent elements. Reflecting on his working methods in 1997, Paolozzi stated that his sculptures existed as:

> Figures put together from bits, these bits complete in themselves, to be articulated in endless permutations might mimic the very processes that establish other orders invisible and potent.[3]

With this process in mind, one can begin to observe how the elements that form *The Wealth of Nations* are not locked into one configuration, but form part of a series of works. In Edinburgh alone, one can see *The Wealth of Nation's* hands holding rods recurring in *Parthenope and Egeria* (1997), situated outside Edinburgh University's Michael Swann Building; they appear again in the display figures for the *Early People* (1998) at the National Museum of Scotland. However, there are two Paolozzi sculptures that revisit almost the entire collection of elements that form *The Wealth of Nations*. These are *A Maximis Ad Minima* (1998), situated at the Royal Botanic Gardens, Kew and *London to Paris* (2000), now at the Cass Sculpture Foundation. It seems that the process that had been so frustrating for the workers at the Singer Foundry in 1992 – Paolozzi's desire to continue experimenting with different configurations – led the artist to view the structure of *The Wealth of Nations* as provisional. For the artist, the elements had only temporarily found a resting place. For *A Maximis Ad Minima*, the building blocks appear to have been knocked down and stacked again in a pyramid-like formation, while the figure now reclines to the left rather than the right. New elements have also joined the collection of forms to create a more congested structure. For *London to Paris*, the building blocks are collapsed and placed on a wooden railway carriage, as if about to be transported to create new monuments in other cities.

Despite the gigantism of *The Wealth of Nations*, the work seems to wrestle against its monumentality. In the Adam Smith book from which the sculpture takes its title, Smith famously described the self-regulatory potential of the economic system as 'the invisible hand'. In considering Paolozzi's use of a process of endless recombination, one can imagine an 'invisible hand' hovering above the sculpture, as if ready to restructure the elements.

Elly Thomas

3 E. Paolozzi, as quoted in R Spencer (ed), *Eduardo Paolozzi: Writings and Interviews*, Oxford University Press, 2000 (p.325).

Parthenope and Egeria

“ I know very little about these two, although I did find myself inspecting the feet to see if I recognised them. I didn’t. Parthenope’s feet have a crude bluntness I hadn’t seen before. Maybe there’s some research to be done on the different representations of feet? ”

Parthenope and Egeria EU5100, EU5101

DATE: 1996

MEDIUM: Bronze

DIMENSIONS: Parthenope – 3.46m x 1.15m; Egeria – 2.70m x 0.62 m

PROVENANCE: Commissioned by the University of Edinburgh with the support of the Scottish Arts Council and the National Lottery Fund

LOCATION: Swann Building, King’s Buildings (currently at the King’s Building Centre), University of Edinburgh

COPYRIGHT: The University of Edinburgh Art Collection.

© Jonathan Clark Fine Art, Representatives of the Artist’s Estate.

Photography by University of Edinburgh Digital Imaging Unit

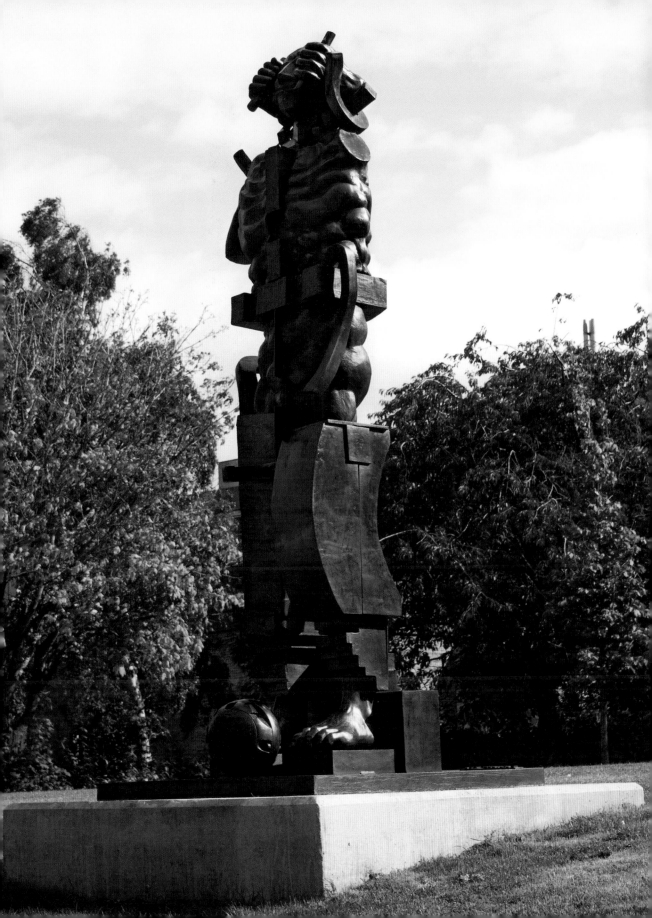

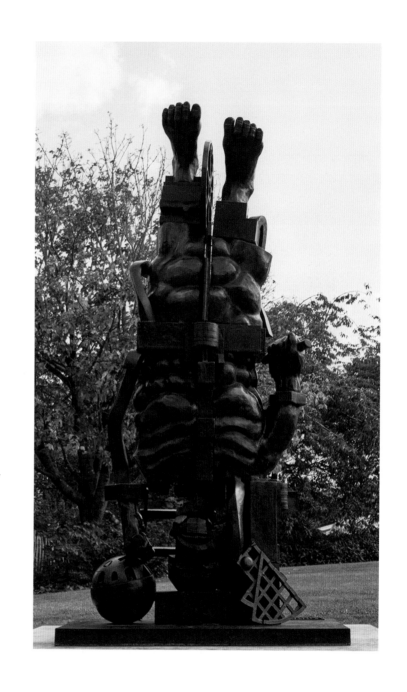

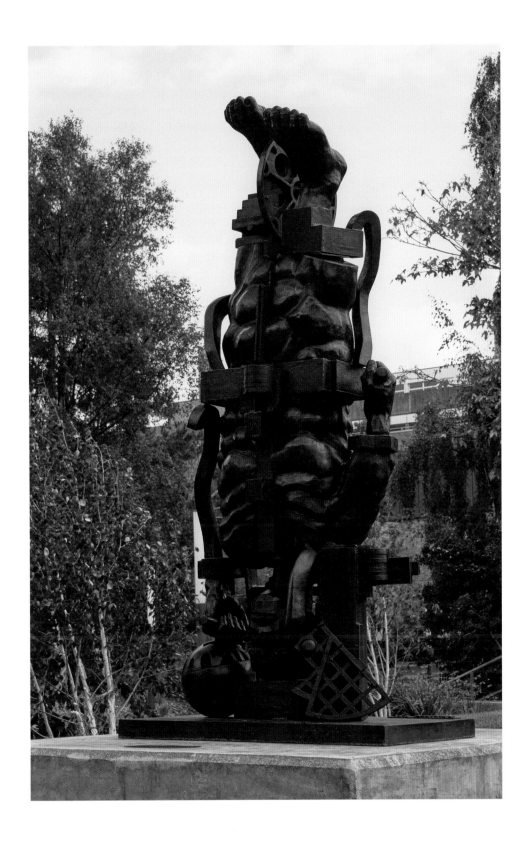

Parthenope and Egeria

Strange to think that, inside, we all look like these two:
links of sausages; globular torsos, corporeal to the core.
And strange that every brain cell remembers to renew
itself over and over, yet unique consciousness endures.
And puzzling to realise we turn the world upside down,
invert images; all that involuntary optics, busy physics.

Thank God for science, for the likes of Newton and all
he discovered: think vision, gravity, laws of motion;
think orbital mechanics. We are what we are:
biological entities; bio-chemical processes; fragments
on the move, welded together through the power
of elusive thought, intangible imagination.

Egeria views the world from a different angle:
she appears to be doing a headstand. Those feet
tramped to Palestine on pilgrimage; see
how beautiful they are, their gospel of peace.
And how strong they are, able to wind up
the heavens, spin the planets.

Parthenope has mislaid her wings and arms
but her thighs are armoured like a wicket-keeper.
With her hard head she measures truth.
Yet she is not without mirth: any minute
she might kick that ball, her name-sake asteroid,
into the yet-to-be-discovered unknown.

Inscription: *Never regard study as a duty, but as the enviable
opportunity to learn to know the liberating influence of beauty
in the realm of the spirit for your own personal joy and to the
profit of the community to which your later work belongs.*
Albert Einstein

Partenope e Egeria

Strano pensare che, dentro, tutti siamo come queste due ninfe:
file di salsicce; torsi globulari, corporei fino al cuore.
E strano che ogni cellula del cervello ricordi di rinnovare
Ripetutamente se stessa, ma resti la coscienza dell'unicità.
E sconcertante rendersi conto che capovolgiamo il mondo,
rovesciamo le immagini; tutta ottica involontaria, fisica attiva.

Sia ringraziato Dio per la scienza, qualcuno come Newton e tutto
quello che ha scoperto; pensate: visione, gravità, leggi del moto;
pensate: la meccanica celeste. Noi siamo quello che siamo:
noi siamo entità biologiche; processi bio-chimici; frammenti
in movimento, saldati insieme per effetto del potere
di pensiero elusivo, di intangibile immaginazione.

Egeria vede il mondo da una angolatura diversa:
sembra che stia facendo un esercizio a testa in giù. Quei piedi
sono andati in pellegrinaggio in Palestina; guardate
come sono belli, il loro un evangelo di pace.
E come sono forti, capaci di provocare la rivoluzione
della volta celeste, la rotazione dei pianeti.

Partenope ha retratto le sue ali e le braccia,
ma ha le cosce armate come quelle di un giocatore di cricket.
Con la sua testa massiccia misura la verità.
Eppure non è priva di divertimento: da un momento all'altro
può dare un calcio alla palla, l'asteroide con il suo nome,
e spedirlo nell'ancora-da-scoprire ignoto.

Iscrizione: *Non guardare mai allo studio come a un dovere, ma come alla invidia-*
bile opportunità di imparare a conoscere l'influenza liberatrice della bellezza nel
regno dello spirito per la tua gioia personale e a profitto della comunità alla quale il
tuo lavoro appartiene.
Albert Einstein

In 1995 Eduardo Paolozzi received a commission from Edinburgh University to make a sculpture to be sited outside the new Michael Swann Building, future home to the Institute of Cell and Molecular Biology, a place where scientists would study the structure and interactions of the basic units of life. Paolozzi was considered a most appropriate artist to fulfil this commission since he worked in a complementary way to that of the scientists; his way of making work was to deconstruct and construct, to improvise, to cut and repair. He wrote of his method in creating *Parthenope* and *Egeria*:

> The body is taken apart and reassembled, readjusted and re-examined. These, by analogy, can be similar to processes in the examination of matter or the pursuit of philosophy or science.[1]

When approached about the commission by Duncan Macmillan, Paolozzi was working on ideas for sculptures on the theme of Chinese jugglers. No work exists that exemplifies this theme of jugglers, but it seems that Paolozzi was planning to make acrobatic figures, concerned with balancing their bodies while juggling numerous objects such as balls. These ideas morphed into *Parthenope* and *Egeria*, a pair of huge and vivacious bronze figures who certainly look as though they are putting on a lively performance for their audience; *Egeria* is even balancing on her head.

They have unusual names, which originate from Greco-Roman times. Although both figures have impressively muscular torsos and look heroic, they portray female characters, a rarity in Paolozzi's oeuvre. The upright one, Parthenope, was a mythical sea nymph, a hybrid of part woman and part bird, who sang songs to try to entice Odysseus away from his journeying. Parthenope was also the original name for Naples. Egeria was a water nymph of springs and fountains, who was the consort of Numa, the second king of Rome. Both females have strong Italian connections, Naples and Rome, which would have appealed to the Latin side of Paolozzi.

Their names have also been given to two minor planets in the asteroid belt, which sits between the planets Mars and Jupiter. In a note on these two figures written in March 1997, the date of their unveiling, Paolozzi remembered that he learned of these two planets 'from an illustration in a school book on Newton, the very apotheosis of genius'.[2]

Isaac Newton was a supremely creative thinker whom Paolozzi greatly admired, obviously from school days, for changing the way we appreciate the world around us, and in the 1980s and 1990s he made dozens of figures of him. While the culmination of Paolozzi's Newton figures was his massive bronze figure of the scientist, unveiled in the courtyard of the British Library in summer 1997, he had used a similar technique for Master of the Universe (1989).

1 Robin Spencer (ed), *Eduardo Paolozzi: Writings and Interviews*, Oxford University Press, 2000, (pp.325–26).

2 Ibid.

The nude bodies of these figures have splits and disjunctures, and powerful muscles sit alongside mechanical elements; they appear as an awesome amalgam of man and machine.

Much the same can be said of the figures of *Parthenope* and *Egeria*, which is not surprising as Paolozzi worked on them at the same time as The British Library *Newton*, and they were unveiled just three months before. Their bodies are interrupted by large geometrical blocks and ribs of metal and *Egeria* has what looks like a part of a sextant beside her head and a wheel between her feet.

Both figures are provided with bronze balls that bear scored lines and rectangular holes. These balls are a reminder of the juggling origin of these figures, but they also allude to another sculpture by Paolozzi, and another creative person that was one of Paolozzi's heroes, Leonardo da Vinci, probably the owner of the most curious and fertile mind of any artist-cum-scientist. When Paolozzi made a large cast iron sculpture, over seven metres long, *Leonardo*, in1986, for the garden of the National Gallery in Munich, it featured large versions of these balls. They owe their form to an illustration that Paolozzi cut out of a National Geographic article, which used these balls to help explain gene division to the reader. Gene division is one of the areas studied in the Swann Building.

The hands of *Parthenope* and *Egeria* grasp small rods, and this is not just an act of holding something decorative. When Paolozzi lived in Munich in the 1980s, he spent every Sunday drawing from the antique Greek sculptures in the Glyptothek museum there. One fragment of antique sculpture caught his eye and mind – a hand holding a short rod – and Paolozzi mused that anyone can pick up a tool, a length of metal, and use it to be destructive or constructive. This ambiguous gesture became a powerful symbol to him of the nature of free will and creativity. It occurs in several of his works from the 1990s, most prominently in another Edinburgh public sculpture, *The Wealth of Nations*.

Paolozzi's work can never be confused with that of any other artist, since his imaginative powers were so fertile, so wide-ranging, and so thought-provoking. As a young artist, he took himself to Paris in 1947 where he was exposed to the surrealist technique of collage, as practised by the leading European artists of the time. What he discovered in Paris was that he had been using the technique of collage, cutting things up and placing them in new configurations and realities, since he was a schoolboy in Edinburgh. It was a rich seam that he mined to the end of his career, and *Parthenope* and *Egeria* stand as compelling witnesses to his singular vision.

Judith Collins

Portrait of Josephine Baker

“ The Josephine Baker statue sited in Selfridges was made by one of EP's workshop assistants, David Field. This statuette is very different; I don't know much about it, although I do know Eduardo admired Josephine Baker, as did Ray. They both liked strong women who knew their own minds; my third daughter, aged about six or seven, told Eduardo she didn't like him much, and it made him roar with laughter. ”

Portrait of Josephine Baker, EU2990

DATE: 1997

MEDIUM: Bronze

DIMENSIONS: 88.0cm high x 20.3cm wide

PROVENANCE: Gifted to the University of Edinburgh

LOCATION: The University of Edinburgh Library, George Square, Edinburgh

COPYRIGHT: The University of Edinburgh Art Collection

© Jonathan Clark Fine Art, Representatives of the Artist's Estate.

Photography by University of Edinburgh Digital Imaging Unit.

Bronze Venus

Facing her, you've moulded defiance,
challenge in the boldness of those eyes.
Side on, her body morphs from male
to female, hard head to graceful heel.

Her arms that danced their way to Paris
were used to begging; and young hands
singed as punishment for wasting soap.
Two more good reasons to omit them?

You catch a softness and resilience:
nerve of street child; metal of woman
– the willing spy for a fitting cause,
invisible ink embellishing music scores.

Smaller than life-size, she stands firm
for Civil Rights; for a grand-mother
in the slave market, poked and prodded;
a price settled, branded *McDonald*.

Lift the lid of the music box, release her.
She'll forgive, will sing and dance once more.
She will not fold away again, but slip that
shackle, those incongruous shoes, and run.

Venere Bronzea

Di fronte, hai modellato in lei l'audacia,
la sfida in quei suoi occhi intrepidi.
Di profilo, il corpo metamorfizza da maschio
a femmina, dalla testa solida al grazioso tacco.

Le braccia che la fecero danzare fino a Parigi
erano use a elemosinare; e le giovani mani
scottate per punizione per spreco di sapone.
Due altre buone ragioni per ometterle?

Tu cogli una morbidezza, una flessibilità:
nerbo di bimba di strada; metallo di donna
– spia volontaria per una buona causa,
inchiostro invisibile che orna spartiti musicali.

Più piccola della sua grandezza naturale, lotta
con fermezza per i Diritti Civili; per una nonna
al mercato degli schiavi, tastata e palpata
un prezzo fissato, marchiata *McDonald*.

Alza il coperchio del carillon, liberala.
Perdonerà, e canterà e danzerà ancora.
Non si chiuderà di nuovo, ma sfilerà quei
ceppi, quelle scarpe incongrue, e fuggirà via.

AFTER GRADUATING FROM the Slade School of Art in 1947, Eduardo Paolozzi relocated to Paris, where he began to move in artistic circles that included such luminaries as Hans Arp, Georges Braque, Alberto Giacometti, and Fernand Léger. A fascination with technology and machinery rapidly became a feature of his sculptural practice at this point, with Paolozzi drawing inspiration from the radical avant-gardism of Dada, and from the found objects of Surrealism. He began to evolve a hybridised creative language, merging organic with mechanistic elements, and creating otherworldly objects that are simultaneously futuristic and primal in form.

A year after his relocation to Paris, Paolozzi attended a live performance by the renowned dancer, singer and entertainer, Josephine Baker. Born in a poor neighbourhood in the East Side of St Louis, Baker aspired to a life on stage, relocating to New York City where she found work as a chorus girl in the ground-breaking black musical, *Shuffle Along* (1921). The Harlem Renaissance heralded a new era of black culture, albeit one that was at odds with the widespread practice of segregation across the United States. White audiences avidly consumed black music in the form of ragtime and jazz: as the poet Langston Hughes observed, 'the Negro was in vogue' in Harlem.[1] While *Shuffle Along* was extremely popular, running for more than 500 performances, Baker was not able to garner the fame she craved in her homeland. She decamped for Paris, where her star power centred as much around her fetishised and exoticised black body as it did her extraordinary stage presence and captivating dance technique.

In Paris, Baker's celebrity status was assured following her performance in Rolf de Maré's *La Revue nègre* (1925). Here, she premiered her cross-eyed Charleston to a thoroughly enthusiastic Parisian audience (the premiere was attended by figures such as Gertrude Stein, Francis Picabia, Man Ray and Jean Cocteau) – a publicity storm somewhat inevitably followed. The Charleston would become a staple of Baker's repertoire, but it was her now-infamous *Danse Sauvage* that perhaps had the most powerful impact, a provocative dance performed in a skirt made of rubber banana skins. The highly sexualised and overtly exoticised nature of the dance was intended to reflect Baker's African heritage, despite the fact she had never visited the continent. The irony of the situation did not pass Baker by; she pithily commented, 'the white imagination sure is something when it comes to blacks'.[2]

Half a century after seeing Baker perform, Paolozzi completed his statuette of the dancer, *The Bronze Venus*. His sculpture is a curious amalgamation of futuristic abstraction and classicism. Baker's expression is jarring – this is not the cross-eyed grin we associate with the well-known still images of her in performance, or the film

1 Hughes, quoted in Bryan Hammond and Patrick O'Connor, *Josephine Baker*, London: Cape, 1988 (p.7).

2 Baker, quoted in Phyllis Rose, *Jazz Cleopatra: Josephine Baker in her Time*, New York: Doubleday, 1989 (p.81).

footage that reveals the speed and precision of her movement vocabulary. Instead, there is a blankness that is imposing, almost stern in its unflinching, direct stare. While Baker's head is held erect and almost rigid, her torso is idealised and soft, arguably betraying Paolozzi's idealising gaze. There is no ambiguity that we are looking at the body of a dancer, with her slender torso, long, muscular legs, and highly-arched feet enclosed in what appear to be precipitously high heels. Nonetheless, The Bronze Venus cannot be described as a traditional rendering of Baker. The head is adorned with curious mechanical embellishments, and the facial features are sharply carved, creating an angular, abstracted impression of the dancer. Looking at Paolozzi's Baker face-on, the viewer might indeed be transported to the 1920s, but to the environs of Fritz Lang's seminal Metropolis rather than Baker's glamourous world of the theatre.

The Bronze Venus is an unsettling and captivating work, one that demonstrates Paolozzi's fascination with the mechanised, robotic body, while simultaneously referencing the Western classical tradition – Baker's missing arms here recall the sculptural relics of classical antiquity. The distinct forms that, merged together, create Baker's body are automaton-like, bordering on an impression of the post human. Her head is strikingly reminiscent of Raoul Hausmann's Spirit of Our Time (1920), both featuring curious assemblages of organic and inorganic parts. Her slender dancer's frame is oddly accented by mechanistic curves and bulges as well as sharply-defined angles and linear planes. Paolozzi's recurring desire to deconstruct the human body is plain to see here; his vision of Josephine Baker is dismantled and reassembled in a cubistic, futuristic manner. We are looking at the dancer through his eyes, and the reflected image is uncanny, almost inhuman. The Bronze Venus is an amalgamation of influences from Paolozzi's short residence in Paris during a period of artistic ferment and upheaval: the robotic form of the sculpture derives from his contemporaries' fascination with the mechanical, while the sensuous, sweeping forms recall his impressions of Baker the performer. He has captured some of the essence of the dancer here, connoting a sense of movement in this static form – Baker stands so high on her toes that she appears as if she is about to take flight.

Paolozzi did not dedicate a significant proportion of his oeuvre to female subjects, a tendency that makes his treatment of Baker here all the more unexpected. Even more striking is the considerable gap between his experience of Baker in a Parisian theatre and the completion of this work. Clearly, the impact of seeing her perform (even at a point when her career was beginning to slowly wind down) left a profound mark on the sculptor, to the degree that he would immortalise her so late in his own life. Josephine Baker's celebrity endures

– she would become recognised almost equally for her passionate civil rights activism as she was for her art. Her image is immediately recognisable, and her influence has been felt in performance culture from the 20th into the 21st century. Paolozzi's tribute to Baker, rendered in his inimitable style, celebrates not only her iconic status as a performer, but presents her as steely, powerful, even intimidating: he presents us with Josephine Baker the warrior; a timeless, ageless, post human figure.

<div align="right">Lucy Weir</div>

Early People

" I wasn't aware that Ray worked much on this project, if at all, but when I look at the figures there are many features that I find familiar... especially the hands and feet. Oh, those feet! But the hands are amazingly powerful; they're often based on Eduardo's own. "

Early People

DATE: 1998

MEDIUM: Bronze

DIMENSIONS: 12 figures in four groups of 3; 2 groups also have a single separate sphere (a comparable sphere is an integral part of 1 of the figures in the other 2 groups).

Group 1: 2 standing figures, each 2.06 m high, 0.80 m wide; 1 bending figure, 1.95 m high, 0.80 m wide; 1 sphere 0.40 m diameter.

Group 2: 3 standing figures, all 2.06 m high but with widths of 0.72 m, 0.75 m, 0.79 m.

Group 3: 2 standing figures, each 2.06 m high, 0.78 m wide; 1 seated figure, 1.86 m high & 0.96 m wide.

Group 4; 1 standing & 2 walking figures, each 2.06 m high but with widths of 0.73 m, 0.76 m, 0.71 m wide; 1 sphere 0.40 m diameter.

PROVENANCE: These figures were created by Sir Eduardo Paolozzi in memory of his friend Barbara Grigor and generously funded by the Society of Antiquaries of Scotland and more than 100 of Barbara's friends and colleagues worldwide.

LOCATION: Early People Gallery, National Museum of Scotland, Edinburgh

© Trustees of the Paolozzi Foundation.

Image © National Museums Scotland

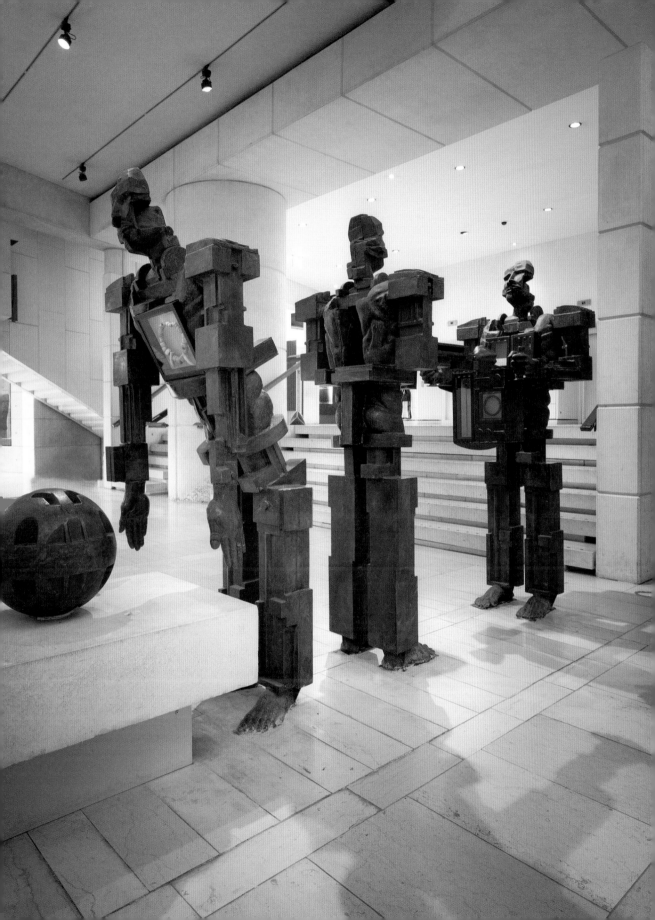

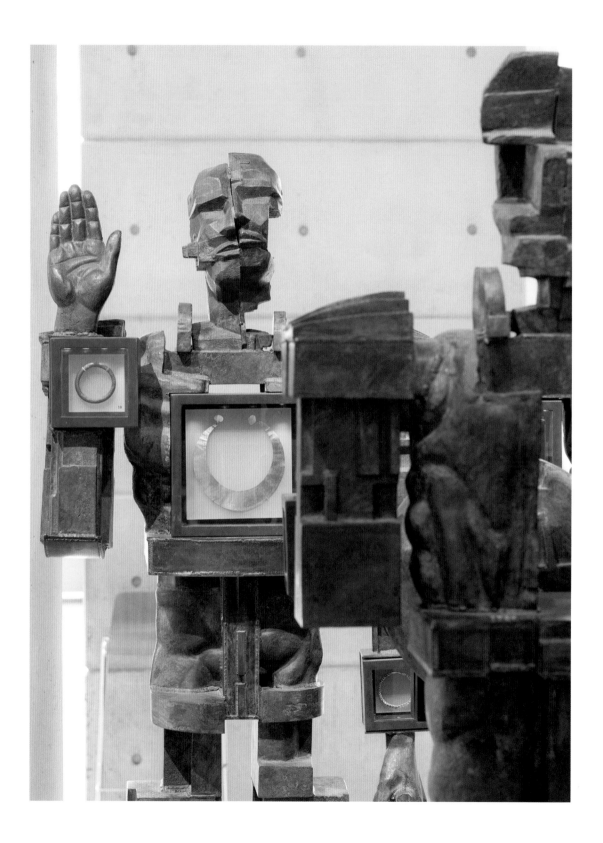

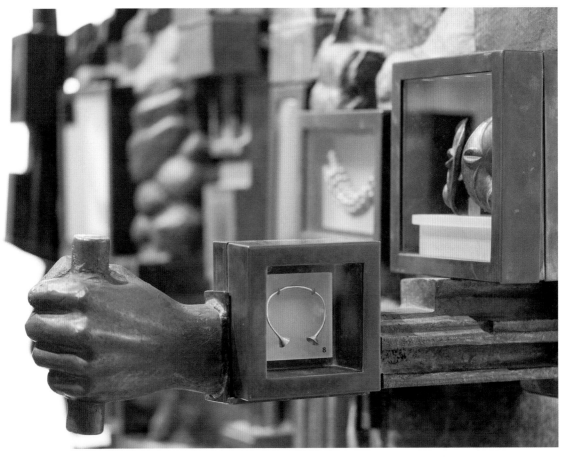

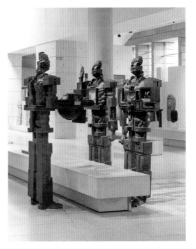

Free movement

1 A Generous Land

We have settled a generous land. Grain is thick
and heavy: bread will bake on a hot stone. It is time
for feasting. Mussels will fall open, seal-meat sizzle.

Let the children wear the bone and tooth necklaces,
play with our ancestors' tools. Who needs them
now we have mastered the art of metal-working?

Our bronze bracelets are prized masterpieces;
our buckles intricately made; our gold rings
so pure their soft twists glint in moonlight.

2 Wider Horizons

Our feet are weary but we raise a hand in peace.
We have walked to far horizons, to where
your people meet our people. We wish to trade.

Feel how weighty our goods are – can you lift them?
You want that gold collar? It is indeed fine. We will
exchange it for that jet necklace and bronze bangle.

We have barley and salt pork to offer too.
What will you tender for them? We have
our eye on your linen and nettle fabrics.

3 Them and Us

We come in power, dressed in our best jewellery
to impress you. We follow our leader, our ruler,
his hand on the orb. He has chosen to pin

the silver brooch next to his heart. They say
it was made in Ireland, inlaid with red glass and gold.
It will pass through many hands on its way to Orkney.

You will not find finer gold or silver bracelets
though you trade the length and breadth of this land.
See the elegance of our hair ornaments and rings.

4 In Touch with the Gods

We come in awe, bearing goods fit for a grave:
amber necklace, gold toe ring, old bracelet of bone.
We have a staff to steady our faltering feet.

This is our final, our inner journey. We step down
into an unknown. We will leave our treasures behind.
We are in touch with the gods, hoping they will bear us

gently to the other side. We will not look back.
Now others will lead the tribe: work and trade,
keep our traditions; make wondrous new things.

Libero movimento

1 Una terra generosa

Ci siamo stanziati in una terra generosa. Il grano è folto,
e pesante: il pane cuocerà su una pietra rovente. È tempo
di fare festa. Si aprono i mitili, sfrigola la carne di foca.

Che i bambini si adornino di collane di denti e di ossa,
giochino con gli arnesi degli antenati. Chi ne ha bisogno
ora che siamo maestri dell'arte di lavorare il metallo?

I nostri bracciali di bronzo sono capolavori di pregio;
le nostre fibbie di fattura intricata; i nostri anelli d'oro
così puri che le dolci spirali brillano al lume della luna.

2 Più vasti orizzonti

Sono stanchi i piedi ma alziamo le mani in segno di pace.
Abbiamo camminato fino ai lontani orizzonti, fin dove ora
la vostra gente incontra la nostra gente. Vogliamo scambi.

Sentite come sono pesanti le nostre merci – potete sollevarle?
Volete questa collarina d'oro? Davvero bella. Ne facciamo
baratto con quella collana di giaietto e cerchi di bronzo.

Abbiamo anche orzo e maiale salato da offrire.
Voi, per quelli, cosa date in cambio? Noi abbiamo messo
gli occhi sulle vostre stoffe di lino e di ortica.

3 Loro e noi

Veniamo in potere, con indosso i nostri gioielli migliori
per suscitare stima. Seguiamo il nostro capo, nostro sovrano
la mano sul globo. Lui ha scelto di appuntarsi

la spilla d'argento vicino al cuore. Dicono
sia stata fatta in Irlanda, intarsiata di vetro rosso e oro.
Passerà per molte mani lungo la strada verso le Orcadi.

Non troverete bracciali più fini d'oro o d'argento neanche
se farete scambi in lungo e in largo per tutta questa terra.
Vedete l'eleganza dei nostri ornamenti per i capelli e gli anelli.

4 In contatto con gli Dei

Veniamo in reverenza, portando beni degni di una tomba:
collana d'ambra, anello d'oro da piede, antichi bracciali d'osso.
Portiamo un bastone per mantenere saldo il passo incerto.

Questo il nostro viaggio finale, il nostro viaggio interno. Scendiamo
dentro un inconosciuto. Lasceremo i nostri tesori dietro di noi.
Siamo in contatto con gli dei, e speriamo che ci accolgano

dolcemente dall'altra parte. Noi non guarderemo indietro.
Ora altri guideranno la tribù: il lavoro e il commercio,
manterranno le tradizioni; faranno nuove cose meravigliose.

MUSEUMS HELD A particular attraction for Eduardo Paolozzi throughout his life. He took opportunities to engage with the issues of museum display, most notably his *Lost Magic Kingdoms* created in 1985 at the, then, Museum of Mankind. These were inevitably temporary shows. But the figures he created for the *Early People* display in the National Museum of Scotland were the only occasion that allowed him to provide an artistic commentary on the key narratives of a major 'permanent' exhibition. For 20 years they have provided an intentionally startling and challenging introduction to the archaeological displays that range from the first human groups after the end of the last ice age, to the Viking raids and settlement at the end of the first millennium AD, a period of some nine thousand years. During the first eight of those nine thousand years, human images are virtually absent from the Scottish archaeological records. Even when they start to appear in the first millennium AD, they are, with few exceptions, abstract figures. Paolozzi's pieces, themselves abstracted versions of the human figure, provide a substitute for the images we lack and provide a playful counterpoint to those we have.

The exhibition does not, though, take the dull chronological plod so common in archaeological displays, adopting instead a thematic approach. The overall structure is provided by four conceptual themes and it is to these that Paolozzi's figures offer an essential introduction. The four themes are gathering and processing resources, staying alive, *This Generous Land*; contacts with the wider world, *Wider Horizons*; power and social organisation, *Them and Us*; and death, belief and ritual, *In Touch with the Gods*. Each of these themes is represented by a group of three figures. The journey between the groups highlights the central concern of each theme while illustrating their relationship with one another and their consequent position within the exhibition. Each group makes use of the associated concrete benches. In *This Generous Land*, the opening figure holds a rectangular sheet bronze box, transformed by the third figure, working on the concrete workbench, into a solid bronze sphere. The sphere remains a key element in the other groups. The figures for *Wider Horizons* face each other on either side of the concrete bench, here symbolising frontier or boundary. One figure offers the sphere, the exchange of resources between groups. One of the other figures on the other side has a hand up in an ambiguous gesture that can mean either 'hello' or 'stop'. In *Them and Us*, the concrete bench has become a throne. The figure sitting on it has a hand on the sphere, the control of resources. Two enforcers stand behind as the guarantee of authority. And finally, for *In Touch with the Gods*, the concrete bench reflects the many paths to salvation and the search for understanding the cosmos. The sphere is no longer in contact with any of

the figures, representing the surviving material culture from which archaeologists attempt to make sense of the prehistoric and early historic past.

Yet the contribution of the figures is not restricted to this important role of epitomising the key messages and summarising the structure of the exhibition. Focus group studies had reinforced and expanded our understanding of the assumptions our visitors bring to displays of the prehistoric and early historic past, and the difficulties they have in coming to terms with worlds very different from their own. The figures were consciously intended to challenge assumptions about, and provoke thought around, issues linked to this distant past. The use of groups of three figures for each conceptual theme was also conceived as reflecting upon a key point in the interpretation of prehistory and early history – that what we are observing in the available evidence is essentially the action of groups rather than individuals. Perhaps the nearest we come to seeing the individual is through pieces of jewellery, though even here we cannot be certain that they were individually owned. Nevertheless, we decided that incorporating real items of jewellery in the figures would provide an important way to link them with the rest of the displays. Paolozzi's ready willingness to have his figures modified to incorporate these artefacts was central to establishing his art as an integral and important element in the exhibition. The jewellery is mounted on the figures at the point where we believe it to have been worn, so bracelets at the wrist, etc. There was a further unanticipated benefit from this decision to build jewellery into the figures. Because people essentially in the same size range as us wore the pieces and each item required an individual case, the figures had to be one and a quarter life-size. This meant that they were taller than the visitors, most of who, our focus groups told us, thought of the people of prehistory as squat, grunting savages. We hoped that the size of the Paolozzi figures might challenge this assumption. The final figure in the group for In Touch with the Gods was left without any jewellery to reinforce the difficulty of recognising the individual in these periods.

Although clearly human, the abstracted nature of the figures enabled us to avoid decisions about matters for which we have little or no evidence. We know nothing about the treatment of hair and we don't know very much about clothing in prehistory. These would normally be key issues in any attempt to represent people of the time. The character of the figures paradoxically enabled us to provide a more accurate representation of the extent of our information. The capacity of the figures to provide commentaries at so many different levels is perhaps reflective of their creator. Paolozzi's family background as immigrants is inevitably a component in his work.

This personal element offers a microcosm of the worlds these figures represent. The snowy, uninhabited wastelands of the last ice age meant that everyone in Scotland is the descendant of an immigrant. These figures represent both the immigrants and their descendants struggling to come to terms with life in a new land, an experience Paolozzi knew well.

David Clarke

Vulcan

" Ray and I were living in separate counties when Vulcan was built, but it reminds me of the tin model of Battleship Potempkin that Ray made for the Spellbound installation at the Hayward Gallery, 1996. It's the silver ship on the right as you stand at the entrance to the studio; we ate an awful lot of tinned tomatoes to provide the material for prototype models. Ray also made a number of tin models for the Museum of Mankind exhibition; more tomatoes. Oh, and peaches too. "

Vulcan

DATE: 1998–1999

MEDIUM: Welded steel

DIMENSIONS: 7.30 m high

PROVENANCE: Commissioned from the artist by the Director-General of the National Galleries of Scotland, 1999. Purchased with the assistance of the Patrons of the National Galleries of Scotland.

LOCATION: Modern Two, Scottish National Gallery of Modern Art, Edinburgh

COPYRIGHT: © Trustees of the Paolozzi Foundation, Licensed by DACS 2017

Collection of the National Galleries of Scotland.

Photography by Antonia Reeve

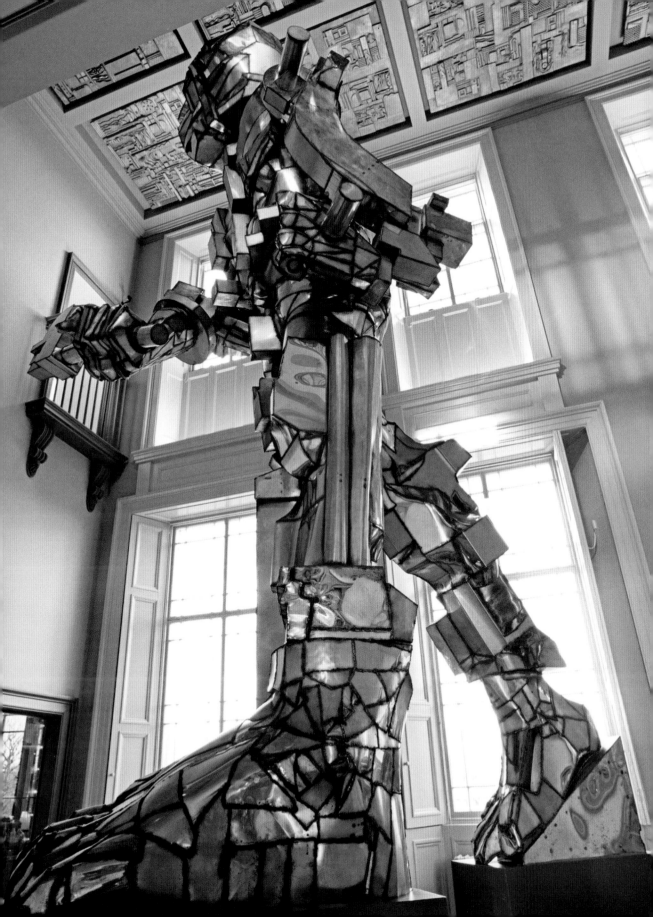

Meeting Vulcan

You are daunting, Vulcan, towering above me.
Art shows magnificence well within your grasp
as with your gammy leg and platform heels
you stride the shining hall, hammer in hand.
We could do with you in goal for Scotland:
4 six-footers barely have your reach, your metal.

You were top-drawer: son of Juno and Jupiter,
the royalty of gods. But in her regal eyes
you didn't make the bonnie baby grade.
There's something vulnerable still lurking
that brings out the mother in me. I want to
shine your steel, make you gleam and sparkle.

You could be the patron saint of blacksmiths
as you were first to find the skills and secrets
of the craft. Or perhaps for single mothers,
in praise of Thetis who rescued you from
your abandonment, and brought you up;
never noticed you were ugly or deformed.

Or maybe you should be the patron saint
of all those judged too flawed; of those whose
inner strength and spirit is what truly counts.
Stride on, half-man and half-machine, under
those majestic heavens. The more I look at you
the more I see a beauty in your fabled strength.

Incontro con Vulcano

Tu incuti soggezione, Vulcano, torreggiante su di me.
L'arte mostra bene la magnificenza in tuo possesso
mentre con la gamba zoppa e le zeppe ai talloni
incedi nella sala splendente, con il martello in mano.
Ci andresti bene a marcare in meta per la Scozia:
4 rugbisti di sei piedi non hanno la tua presa, il tuo metallo.

Tu eri nato in alto: figlio di Giove e Giunone,
la famiglia reale degli dei. Ma ai loro occhi regali
non raggiungevi il grado di bel bambino.
C'è qualcosa di vulnerabile in te, nascosto ancora,
che tira fuori la madre in me. Mi viene voglia
di lustrare il tuo acciaio, farti brillare e fare scintille.

Tu potresti essere il santo patrono dei fabbri
poiché sei stato il primo a scoprire trucchi e segreti
del mestiere. O forse patrono delle madri sole,
in onore di Teti, che ti ha messo in salvo
dall'abbandono, e ti ha fatto diventare grande;
e non ha mai notato se eri brutto o deforme.

O forse dovresti essere il santo patrono
di tutti coloro giudicati troppo imperfetti; coloro di cui
forza interiore e spirito sono quello che davvero conta.
Incedi sempre, per metà uomo e metà macchina, sotto
queste maestose volte. Più indugio a guardarti
e più vedo una bellezza nella tua favolosa forza.

LET'S START AT THOSE TOES: surrounded by tables and the clatter and hiss of café service, *Vulcan*'s feet are the first part you see as you enter the Great Hall. Then look up, and survey 23 feet of welded steel spanning two floors, confined by architecture, striding nowhere. Machine-like but emphatically man-made, this steel sculpture dominates the space, a science fiction interloper squeezed into a neo-Classical building.

Paolozzi took as his subject the Roman god Vulcan: ugly and ill-tempered but highly skilled, he forged weapons and jewellery for his fellow gods. His mother Juno had been horrified by the infant Vulcan's appearance and tossed him from the peak of Mount Olympus: he fell for a day and a night, breaking a leg on impact which rendered him lame. This seam of classicism runs through Paolozzi's work, with *Vulcan* in particular (and his Greek counterpart, Hephaestus) becoming a recurring subject from the mid-'80s. At the time he taught at the Akademie der Bildenden Künste in Munich, home to the Glyptothek Museum:

> [I have been] very moved by the most beautiful Greek museum that's ever been built, the Glyptothek in Munich. I'm moved by the details of these hands and feet in cabinets and how magical they are. I'm trying to reverse the process by having these elements and re-assembling them in a diagram of modernity.[1]

Vulcan embodies these attempts at re-assemblage; although the subject may be classical, Paolozzi draws on science fiction imagery to re-present him in futuristic form. But despite fusing *Vulcan*'s deific nature with robotic strength, Paolozzi emphasises his physical infirmity by pairing his front foot with a smooth, crutch-like stanchion, highlighting his lameness (and necessarily supporting more than five tonnes of steel). Indeed it may have been this physical vulnerability that primarily appealed to Paolozzi. As Hal Foster writes:

> Paolozzi styled some of his sculptures after characters in Greek myth, with an emphasis on the defeated and doomed [Cyclops, Icarus etc.]... Conceivably this was what he found heroic in all of his figures, classical, Christian, and other: damaged to the point of death, they still survive or at the very least they persist as the stuff of legend.[2]

Icarus (First Version) (1957), *St Sebastian I* (1957) and *Daedalus on Wheels* (1991) can all be found in the National Galleries of Scotland's collection, bronze figures seemingly subjected to profound psychic and physical trauma.

Vulcan in situ

Paolozzi's sculptures dominate Modern Two, ranging in scale from the colossal *Vulcan* in the Great Hall to the small plaster casts and

1 Spencer, R (ed), *Eduardo Paolozzi: Writings and Interviews*, Oxford University Press (p.329). Paolozzi taught at the Akademie der Bildenden Künste between 1981 and 1994.
2 *Eduardo Paolozzi*, Whitechapel Gallery, London, 2017 (p.33).

PAOLOZZI AT LARGE IN EDINBURGH

bronze maquettes, which crowd the hallway cabinets and the Paolozzi Studio recreation on the ground floor. A former orphanage designed by Thomas Hamilton in 1831, the building was given to the National Galleries of Scotland by the City of Edinburgh and Lothian Council and converted by Terry Farrell and Partners into an art gallery in 1999. Initially the building had been intended as, effectively, a Paolozzi museum, conceived in conjunction with the artist himself. Paolozzi's original vision was an attempt to radicalise the traditional concept of the museum. As he said in 1995:

> It will be used as a platform for all kinds of things that are necessary in Scotland now... It will be busy, noisy and active'.[3]

But the wisdom of dedicating an entire gallery to a living artist was questioned by both the press and the parties involved, and the idea of a Paolozzi museum was quietly dropped. Regardless, the artist donated a significant gift to the National Galleries of Scotland, comprising over 100 maquettes, models and sculptures, around 2,000 prints, 500 drawings, 9,000 photographs, 3,000 slides and a significant quantity of archival material. In 1997, the National Galleries of Scotland commissioned Paolozzi to create a sculpture specifically for the Great Hall: Vulcan's 23 feet of welded steel has dominated the building since it opened in 1999.

Constructing a God

Vulcan was assembled and welded together in the Great Hall itself; though born to Juno and Jupiter, this deity is decidedly man-made. His jagged seams emphasise the process of his creation, with electrical welding creating a burnished effect in the joins between stainless steel sheets. In the initial stage of its conception Paolozzi sculpted Vulcan as a small clay model, which was formed first in plaster and then cast in bronze. This bronze maquette was given to John Crisfield of The Sculpture Factory in Clerkenwell, who constructed the sheet metal panels and worked with Paolozzi on the final figure. Vulcan's steel panels were then transported north in two lorry loads and welded together in situ over an armature, before his head was placed using a block and tackle.

Paolozzi was commissioned to build similarly large bronze Vulcans for Newcastle and London around this period,[4] and a pantheon of Vulcans and Hephaestuses exists in small-scale plaster and bronze form throughout Paolozzi's oeuvre. Paolozzi acknowledged this thematic repetition:

> All these gods and heroes with their broken limbs and mutilated faces, convey their own experience of time, which I find very moving... One keeps coming back to original obsessions.[5]

3 Paolozzi, E, 'Glynn Williams Talks to Eduardo Paolozzi', Sotheby's Art at Auction: The Art Market Review, London, 1994–95 (pp.40–46).

4 A 7-metre tall Vulcan was installed in Central Square North, Newcastle in 2000; an 8-metre tall version at Royal Victoria Docks in 1999.

5 Paolozzi, E, Eduardo Paolozzi: Writings and Interviews (p.viii).

Vulcan was described at the time of the gallery's opening as a 'voracious devourer of everything that comes his way',[6] a characterisation which could equally be applied to the ever-curious Paolozzi. Although he died in 2005, Paolozzi's *Vulcan* remains a testament to two creators: the Roman god himself, and the sculptor who conceived him.

Kirstie Meehan

6 Livingstone, M. 'Edinburgh, Surrealism; Paolozzi; Arikha' review in *The Burlington Magazine*, Vol. 141, No. 1156, July 1999 (p.434).

Millennium Window

“ The windows are wonderful... but there's a certain sadness behind the life-affirming glory of the colours, as by the time the windows were dedicated Eduardo was suffering very much from the after-effects of his stroke. ”

Millennium Window

DATE: 1998 (installed 2002)
MEDIUM: Stained glass
DIMENSIONS: *central lancet* – 6.5 m x 1.2 m; *side lancets* – 6.0 m x 0.7 m; *rose window* – 5.7m in diameter
PROVENANCE: Commissioned by St Mary's Episcopal Cathedral
LOCATION: St Mary's Episcopal Cathedral, Edinburgh
St Mary's Episcopal Cathedral.
Photography © Dave Sands

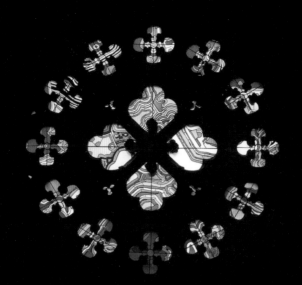

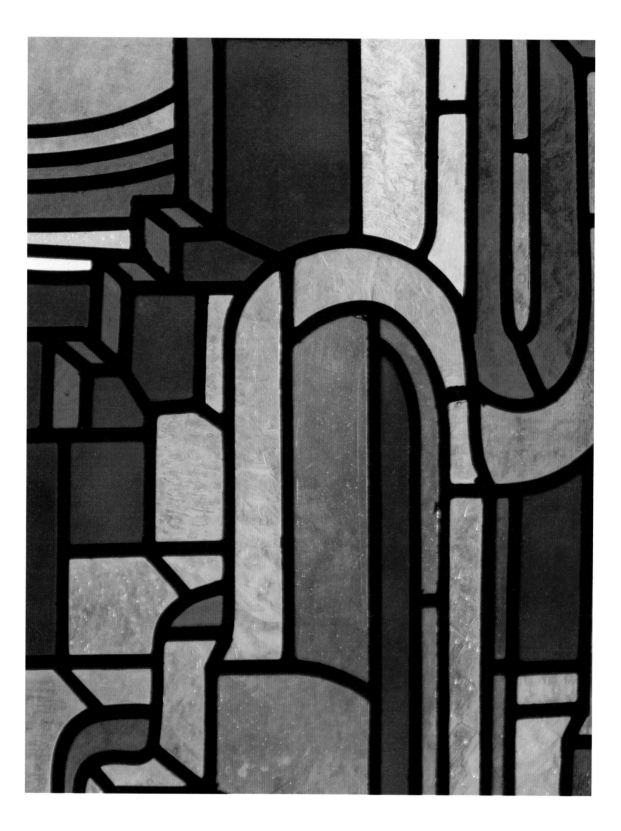

Naomi

Eduardo Paolozzi 2002

Like a Flaring Thing

> *... speech alone*
> *Doth vanish like a flaring thing*
> *And in the eare, not conscience ring.*
>
> George Herbert 'The Windows'

Dumb-struck, the old man in the wheel-chair sits
in the Resurrection Chapel, scans his work in situ:
the Ascension window – three lancets and a rose.

Any minute now the crowds will gather where
the glass-maker has brought his design to life: cut
and painted, matched tones exactly; captured
the numinous in emerald, cerulean, ultramarine;
in terracotta, jade and azure, in flaming carmine.
Lead cames clasp the vivid pieces so they ribbon
and wave, stack in blocks, in steps and stripes:
a city rising, an ocean; a dazzle, a hint of heaven;
a prized mosaic, a map of a blissful unknown.

The rose window – that grand *oculus* – stencils
the sun as it crosses the morning sky, rich
and glorious. Light washes the cathedral,
softens stone, tie-dyes all who enter.
They are strafed by its splendour.

 The dedication begins:
Tremunt videntes angeli: MacMillan has crafted
a soundscape of the eternal; no need for
utterance. The nave is shot with radiance,
beyond points of colour or notes on a stave,
beyond closed minds or deadened hearts.

The old artist can only nod. The sun plays
on stone; the holy space ablaze.

Come una vampata ardente

... la parola da sola
Svanisce come una vampata ardente
E nell'orecchio non risuona la coscienza

George Herbert 'Le Finestre'

Ammutolito, quell'uomo vecchio sulla sedia a rotelle siede
nella Cappella della Resurrezione, esamina il suo lavoro *in situ*:
la finestra dell'Ascensione – tre lanceolate monofore e un rosone.

Da un momento all'altro le folle gremiranno il luogo
dove il mastro vetraio ha dato vita al suo disegno: tagliato
e dipinto, accostato tonalità esattamente; catturato
il noumenico nello smeraldo, nel ceruleo, nell'ultramarino;
nel terracotta, nella giada e nell'azzurro, nel carminio fiammante.
Legature di piombo incastonano i pezzi vividi che si schierano
oscillano, si accumulano in blocchi, in righe e in gradini:
si eleva una città, un oceano; un bagliore, un cenno di paradiso;
un mosaico di pregio, una mappa di un beato ignoto.

La vetrata a rosone – quel grandioso *oculus* – stincilla
il sole quando attraversa il cielo mattutino, ricco
e glorioso. La luce lava la cattedrale, ammorbidisce
la pietra, su tutti quelli che entrano opera una tintura a nodo.
Sono mitragliati da tutto quello splendore.

La dedica ha inizio con:
Tremunt videntes angeli: MacMillan ha fabbricato
un panorama sonoro dell'eterno; non servono altri
pronunciamenti. La navata è cosparsa di fasci di luce,
oltre i punti di colore o le note sul pentagramma,
oltre le menti chiuse o i cuori morti alla sensibilità.

Il vecchio artista può soltanto fare cenni col capo. Il sole
tocca la pietra; lo spazio sacro divampa.

DEDICATED IN OCTOBER 2002 and so a little more than a year after Eduardo suffered the stroke that so tragically disabled him, the three lancets and the rose window that he designed for the Resurrection Chapel (and south transept) of St Mary's Episcopal Cathedral in Edinburgh were together the last major work that he completed. He called the three lancets after his three daughters, but using their middle names, Carmela, Francesca and Naomi, each inscribed on the glass in his hand at the bottom of the appropriate window. His signature and the date 2002 are also inscribed by the same method in the bottom right-hand corner of the right-hand window. Grand and luminously beautiful, the windows are indeed a fitting swansong for a great artist.

The project was the initiative of the Cathedral's then Provost, the Very Rev Dr Graham Forbes. He first proposed the idea to the Cathedral Board on 25 August 1998 saying:

> I am actively exploring the possibility of commissioning a Millennium Window to replace the plain glass in the Resurrection Chapel. Some kind of costings should be available shortly. Ideally substantial savings should be possible through Heritage Lottery Fund (HLF) – which includes a 'glass allowance' – and through an application to the Millennium Commission itself. Sir Eduardo Paolozzi has been quietly sounded out and is excited about the prospect. ... I will see him next month and talk numbers – everything at this stage is purely exploratory.[1]

In a recent conversation, the former Provost, Graham Forbes, recalled Eduardo's anxiety about working in stained glass for the first time and also about being exposed to 'official' criticism. (He surmises that this might reflect the reception Eduardo's proposals for a set of bronze doors for the High Kirk of St Giles, also in Edinburgh, had received, a project which was then current, but sadly was never realised.) The Provost was able to assure him that his design would not have to go through endless bureaucratic hurdles. (Though it did have to be approved by Historic Scotland, they had indicated their support from the beginning.) The project was carried out by Phoenix Glass Ltd, Edinburgh, under the direction of the company's owner Mike Fenton. He was assisted by Marianna Wren and Amanda Baron (now Bennett) who undertook drawing to scale, selecting and painting the glass. The windows were cut and built by Mike Fenton's team and later installed by Les Barrie assisted by Andrew Johnston. Andrew Johnston later acquired Phoenix Glass from Mike Fenton. (The first lancet to be made was actually too small and had to be remade. The original was divided among the artists involved which explains why there may be fragments of a Paolozzi stained glass window in circulation.)

1 St Mary's Cathedral Archive.

Fiona Mathison oversaw the project on behalf of Eduardo Paolozzi and arranged studio visits with him before and during its construction. Sadly he suffered a stroke towards the end of the project.

Phoenix Glass had also recently undertaken the restoration of all the windows in the cathedral. Fabrication of the new windows took a full year after all the necessary formalities were complete. They were then installed during 2002 in time for the October dedication. Proposing the project, Graham Forbes mentions a 'glass allowance' in HLF funding and in the event the cost was included in a conservation project that covered the entire fabric of the cathedral, funded by the HLF and Historic Scotland with a contribution from members of the public and of the congregation. Characteristically, Eduardo himself took no fee.

From his own testimony given below, Eduardo reflected deeply on the project and by 16 September 1999, when he wrote to Graham Forbes describing his design, it was evidently pretty much complete:

> The eye moves, the eye follows the waves of movement upwards towards the Heavens, interrupted unpredictably by various phenomena. The colours are those of the Skies and the Seas. The symmetry acts as counterpoint to the movement of the Creation. Small geometries indicate the presence of Man, Other Inventions, Fire and Water.[2]

On 23 March 1999 he had written to the same correspondent:

> I spend some time each day on the theme and colours of the stained glass windows project for St Mary's. I have been paying particular attention to the idea of reflecting deep religious experiences objectified or even immortalised in shapes and colour.

What he had created was a set of cartoons that could be used by the craftsmen to make and then install the windows, or lead lights as they are properly called. (Cartoon is the traditional term for an artist's paper model, actual size or to scale, for a large-scale work like a window or mural painting.) Eduardo made collages of all the glass using intricately cut-out paper, brilliant in colour and with a variety of textures. He had also coloured much of it himself in crayon and pen creating more variety of texture and passages with greater transparency.

At the time of writing there is some uncertainty about the current whereabouts of the original cartoons and of any working copies (scaled or otherwise); and indeed what may, originally, have been handed over from the artist to the Cathedral Committee and subsequently presented by Graham Forbes to the Scottish National Gallery of Modern Art. There are however colour photocopies in the NGS of the cartoons enlarged to scale on a drawing of the transept wall.

The wall of the transept that bears the windows is south-facing and, as well as being named for his daughters, in sequence and following the movement of the sun, the three lancets represent

2 St Mary's Cathedral Archive.

morning on the left, noon in the centre and evening to the right. Morning reaches up towards the light. It has more white glass than the other two and this is particularly striking in the upper section. Evening is richer in colour and reaches upwards to terminate in the pink of sunset and the deep blue of nightfall. Both these windows have highlights of bright red, turquoise and cobalt. Noon, the central lancet, is wider and taller. (The dimensions of the central lancet are 6.5m high by 1.2m wide while the two side lancets windows are 6.0m high by 0.7m wide.) Appropriately for the window in the noonday position, its colour is deeper, especially at the foot where the pattern is also more dense. The leading is delicate throughout, but also varied in thickness. Though this is scarcely discernible to the naked eye, it nevertheless enhances the lightness and airiness of the overall effect.

The rose window above (5.7m in diameter) is composed of 20 individual elements including four so tiny they are little more than pinpoints of bright colour. The 12 cruciform, outer lights are in rich, dark colours. The deep pink, particularly prominent here, is especially beautiful. In the four central elements, the colour is lighter. In striking contrast to the resolved unity of the lancets, the individual compositions of the elements of the rose window suggest they are glimpses of a single, larger composition that is otherwise hidden from view. It is as though they are radiant hints of some greater, transcendental vision that lies beyond. Looking at the cartoon it seems that these elements have indeed been deliberately cut out of a larger composition. The luminous brilliance of the whole group is in marked contrast to the heavy effect of the Victorian windows, burdened with narrative, typical of our churches and indeed of many of the other windows in St Mary's. This contrast illustrates something that Eduardo himself was quite clear about. Matisse's windows in the Rosary Chapel at Vence, some of the finest modern stained glass ever made, and which he had often visited, were an important part of his inspiration.

Throughout, the elements of the design are abstract and so recall previous work where Eduardo explored the analogy between art and music. Nevertheless he did tell Graham Forbes that his design was inspired by the heavenly ladder in Jacob's Dream. There are certainly ladder and step forms in the lancets. There are also wavy lines surging upwards in all three. These are no doubt what Eduardo refers to as 'waves of movement upwards' and the effect throughout is of energetic vertical movement. However there are horizontal incidents too; perhaps what Eduardo calls 'small geometries'. Without actually obstructing the joyous verticality, they suggest that it is not simply effortless. It triumphs, but not without struggle. The idea of the ladder which led up to the celestial vision in Jacob's dream also

chimes beautifully with the hint of a transcendental vision glimpsed behind the high rose window to which these ladder-lancets lead us. Although rising into glory like this is more appropriate to the Ascension than to the Resurrection, it is nevertheless also in keeping with the dedication of the transept as the Chapel of the Resurrection.

It is clear from what Eduardo says, that the windows – his only work in stained glass – had a profound meaning for him. It is also clear that he engaged deeply in the project, not perhaps specifically with religion, but certainly with the human need for the spiritual. This reflects an important aspect of his thought. It links the windows with, for instance, the exhibition *Lost Magic Kingdoms*, held at the Museum of Mankind in 1985. He often remarked how important this exhibition was to him. In it he had selected work from the Museum's collection to illustrate the myriad ways in which, properly liberated, the human imagination seeks to express a sense of the spiritual. Nor can we overlook the meaning of the title that he chose: we have lost access to the imaginative kingdoms to which the artists of the extraordinary 'primitive' works that he selected so clearly still had access. As a society our imaginations are confined, not liberated. However, by placing his own work alongside the works he chose from the Museum's collections as he did, he too was aiming to open up our imaginations towards the spiritual. He is insistent in the introduction to the catalogue of *Lost Magic Kingdoms* that, to achieve this, imaginative fluidity is vital. We must allow our minds to make connections freely, outside and across the boundaries imposed by the rigid and too insistent mental disciplines with which we allow ourselves to be confined. To see the liberation of the imagination as an imperative in this way is the key vision of the Enlightenment; it is where Paolozzi meets Blake. Looking at the windows as they are installed, you see how wonderfully they achieve, not only this necessary freeing of the imagination, but, once freed, the glory it can reveal. Think of Blake's *Dance of Albion*, or *Glad Day* as it is also known, a joyful, leaping figure against a burst of rainbow-coloured light. It is the closest analogy I can find to the St Mary's windows.

In St Mary's the light and colour of the glass is spectacular, but it also reaches beyond the artwork. Here too Matisse's example was important. At Vence the windows flood the chapel with coloured light and this happens in St Mary's too. The windows are south-facing; thus, in the middle of the day, especially in winter when the sun is low and the trees outside are bare, their radiant light falls far into the church and onto the walls, the columns, the ironwork, the floor and indeed on anybody who is standing there. They perform this miracle of coloured light every day, but they never did so more memorably than on the day they were dedicated. The ceremony was

performed by HRH Princess Anne. Eduardo was there in his wheel-chair. Although I maybe malign the Princess, as I recollect, she omitted to make any mention of the artist at all in her short speech. The omission did not go unremarked in a higher place however. It was a dark day, but as she concluded, the heavens opened and a shaft of brilliant light struck through the windows to fall on Eduardo, picking him out in a glorious rainbow of colour. All else was shadow.

Duncan Macmillan

Studio Reconstruction

66 I visited EP's studio in Dovehouse Street two or three times, and the detail of the recreation is amazing. However, I have to say that the reconstruction fails miserably when it comes to reproducing the smell of the original, and the cluttered floor space. When I was there I found myself crunching over bits of plaster, cut up cardboard packaging, dirty socks, odd sections of pianos and bicycles, musical boxes, broken china ornaments and heaps of postcards and old papers.

When I'm leaning on the barrier in the reconstruction in Modern Art Two I often spot a Barbie or a Ken that I recognise; our household provided (intentionally or unintentionally) various items that ended up in one of EP's studios. Broken dolls and other abandoned toys regularly disappeared... sometimes a little too soon. There'd be a loud wail from a daughter, followed by an explanation that a headless Hulk had gone to be Art – an explanation that didn't always go down too well with an irate five year old. 99

Paolozzi's Studio

INSTALLED: 1999

PROVENANCE: Part of the Paolozzi Gift, given to the National Galleries of Scotland in 1998

LOCATION: Modern Two, Scottish National Gallery of Modern Art

Photography by Antonia Reeve

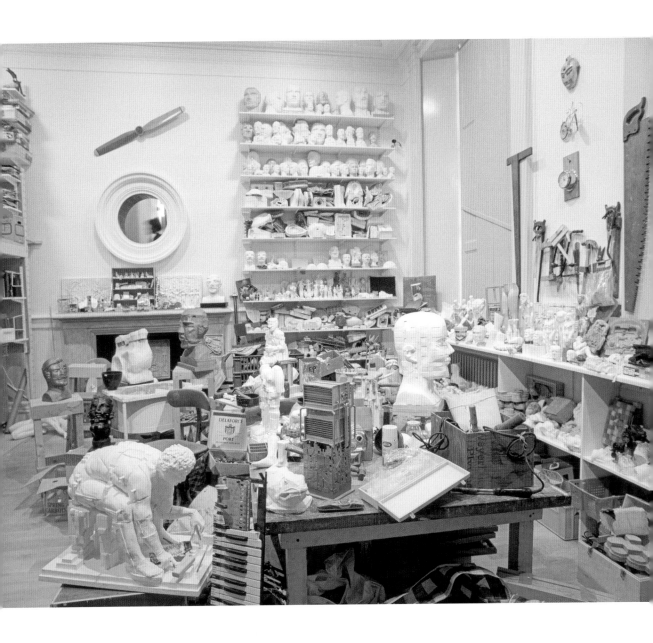

Clamjamfrie

It's a bric-a-brac stall
with a bed for the back shift, a ladder that groaned
at the hassle of chock-a-block days with pencil or clay,
with drilling and bolting; juddered with shock when
a brainwave ignited and you bounding down
to reshape the world, explore the morass.

It's a dolls' house
of a place: crammed with Greek gods and sci-fi and
tenements of torsos, with feet, heads galore; a chair,
camouflaged in a garden of play. The child in us picks out
a spaceship, a cricket, teeth casts, a comic.
And we're stunned at your wonder.

It's a cave
where myth and legend abound, where your mind held
a medley: Daedalus, fellow sculptor, bolted together;
David, remade – perfection and weakness;
Newton, head down, groping for truth; Vulcan ablaze;
the hand and foot-holds of your Mondrian maze.

It's some studio.
This Way Up, That Way Up: whichever, it's explosive,
and all worth **Handling With Care.**

Clamjamfrie: a Scots word – one meaning is *odds and ends, unsorted clutter*

Baraonda

È una bottega di bric-a-brac
con un letto per il turno di notte, una scala che gemeva
sotto la spinta di giorni pieni zeppi di matite e di argilla,
di trapani e bullonature; che sussultava per la scossa quando
una idea si accendeva di colpo e tu eri forzato a impegnarti
per ridare forma al mondo, esplorare la palude.

È una casa delle bambole
un posto così: riempito di dei greci e di pezzi di fantascienza, e
anatomie di torsi; di piedi, un'abbondanza di teste; una sedia
camuffata da parco dei divertimenti. Il bambino in noi coglie
una nave spaziale, un grillo, stampi di denti, un fumetto.
E siamo stupefatti dalla tua meraviglia.

È una caverna
dove mito e leggenda abbondano, dove la tua mente teneva
una festa di incontri: Dedalo, compagno di scultura, imbullonato;
Davide, ricostruito – la perfezione e la debolezza;
Newton, a testa bassa, che persegue la verità; Vulcano ardente;
appigli per mani e piedi del tuo labirinto alla Mondrian.

È un vero studio.
Da questa parte, Da quella parte: da qualunque parte, è esplosivo,
e tutto meritevole di un **Maneggiare con cura**.

THIS CROWDED SPACE represents three studios and a garage filled with material in Chelsea, London. Paolozzi bought the first studio in 1960 in a complex of new, purpose built studios set around a courtyard. Over the next 35 years, the other spaces followed and by 1994 they were full. Paolozzi had enough material to donate for a studio reconstruction in Edinburgh. This dream became a reality thanks to both the work of Sir Angus Grossart, Chair of National Galleries Scotland, and the generosity of the City of Edinburgh Council. What is now Modern Two, built in 1833 as an Orphan Hospital and which latterly had been used as a Local Authority Education Centre, was to be the home of the Paolozzi archive and studio reconstruction. And so it was that, in 1995, two lorry loads were taken to Edinburgh and stored in a warehouse, where they were catalogued and put on computer. There were 3,825 pieces of sculpture, 3,000 books, 6,000 slides and 80,000 tearsheets pulled from magazines; these would provide images to feed into collages and prints, or to give to students at Munich or the Royal College of Art, where he taught.

All of these various objects massed in the studio at Gallery of Modern Art Two are a mirror of the artist's mind. Paolozzi had a book, by Alexander Liebermann, of photographs of artists' studios and he was fascinated to see how each different studio revealed each artist's ideas. He was inspired to suggest the studio reconstruction to the National Galleries of Scotland as a sort of catalyst for people's imagination. In reality, the studios were even more cluttered and the floor was deep in sale catalogues, folders of tearsheets, crates and magazines. The walls were shelved to the ceiling and even the bed platforms had shelves. In the studio where Paolozzi lived, there was a television on the bed platform and a canvas chair in the little kitchen below, where he would sit and cut out pictures in the mornings.

Paolozzi's day began early and, at 7.30am, his assistant Nick Gorse would arrive and they would begin work. At 9.30, they would go to the little Italian coffee shack in the local farmers' market for coffee and croissants, and a look at the papers, The Guardian and The Times. There was much discussion of bizarre news items and laughter. Paolozzi took his mending to the Italian tailor close by who called him 'Commendatore'. Another local haunt was Habitat on the High Street, which had a coffee shop. Sir Terence Conran, its founder, had worked with Paolozzi in the 1950s making furniture. Back in the studio there would be a visit from his model maker, Ray Watson, with waxes or a delivery of prints to be signed. There would be phone calls to be made to The Arch Foundry – a local one – or a visit to the Royal College of Art Foundry in Battersea. Also in Battersea was the warehouse complex of Rodgers, the transport and storage firm used by the Queen. In the Warehouse Paolozzi had stored many bronzes and

there was also a room stacked with print suites. It was Rodgers that came and packed – for ten days – the studio material to be sent to Edinburgh.

Paolozzi himself made the selection of the Edinburgh studio material. As he was removing objects that had played their part in making past works, he was able to let them go. But in some cases, he felt that something was 'hot', meaning it was still sparking his creativity and so kept it. Among the books he kept were those on Auguste Rodin, the French sculptor. He loved his use of body fragments. In the Edinburgh studio you can see hands, feet, teeth, eyes and ears. Rodin's studio at his house in Meudon outside Paris, has still got its storage drawers with similar body parts.

In the Edinburgh studio you can see on the shelves boxes of parts of geometrical shapes called DNA balls which he copied from a magazine illustration. There are fragments of shapes used for the Rhinegarten sculptures in Cologne and elements of the preliminary ideas for *Piscator*, located outside Euston Station in London. The sculptures on the shelves include plaster casts of antiquity from the Glyptotech in Munich where Paolozzi took his students while teaching at the Fine Art Academy there. There are Star Wars kits, some of which he cast in plaster. On the window ledges, there are Adam and Eve figures from his Noah's Ark installation in Munich, made using puppets from a local museum. There are casts of Action Men made into Greek warriors. There are silver figures made as a film award equivalent of Oscars. Over the circular window is a propeller from an aeroplane; Paolozzi said his first sculpture was a propeller. He saw his first aeroplane when he went to youth camps in Italy before the Second World War.

On the table in the middle, there are works in progress such as the seated figure of the scientists; Michael Faraday for the University of Birmingham and Isaac Newton, crouching down, for the British Library in London. Behind these is the plaster trolley holding the raw plaster dust. On the plan chest, under the bed platform, is a Mexican Day of the Dead skeleton in papier-mâché. This serves as a reminder of his *Lost Magic Kingdoms* show in the 1980s, which was a collaboration with the ethnographic collections of the Museum of Mankind in London, which subsequently toured.

On either side of the studio, at the front, are desks displaying how Paolozzi worked in paper, ie cutting, collaging and tearing pictures from magazines, newspapers and sale catalogues. On the wall on the left is a photograph of Paolozzi with Rudi Seitz, the Rector of the Munich Academy of Fine Arts. Seitz wrote a very astute description of Paolozzi's time in Munich in the *Recurring Themes* catalogue of the 1984 exhibition, for the 60th birthday of the artist. His is the only

photo on Paolozzi's studio wall. Seitz, like Anton Ehrenzeig at the Central School of Art and Design, a collaborator in the 1950s, was a psychologist. Paolozzi's library around the bed platform included books on psychopathology, plus art and psychoanalysis by Ernst Kris. The many tearsheets, now housed in a warehouse, included a magazine article on madness with an illustration which Paolozzi was later able to exploit for his art work edition of Baudelaire's *Les Fleurs du Mal*.

The studio reconstruction at the Scottish National Gallery of Modern Art sums up so much of the obsessions that drove Paolozzi to create. Paolozzi was a visionary and he had a global view. The widespread reach of his creations mirrors his mind. He felt that art liberates the mind and he found freedom though creating. His dearest wish was that the studio reconstruction would light the touch paper for other people, especially children, to become creative. He wanted us to look afresh at the world.

Fiona Pearson

Part Two Conversations

Twelve conversations with Sir Eduardo Paolozzi

A selection of works developed by Royal Scottish Academicians (RSA) in response to the work of Sir Eduardo Paolozzi RSA.

Eduardo Paolozzi was an Honorary Member of the Royal Scottish Academy and many of the artists shown here knew him personally as a colleague, fellow artist or tutor. The artists are spread across Scotland and many have taught or still teach new generations of Scottish artists.

These presentations showcase the responses to an invitation from Dr Carlo Pirozzi to make works as part of the Paolozzi in Edinburgh project. These works, by prominent Scottish artists, are personal explorations of the influence Paolozzi had on Scottish art and artists.

THE IMPACT OF THE Italian community in Scotland is well documented. Trade and immigration has brought Italian families to live and work in Scotland. Throughout the 20th century, these waves of immigrants have continued to broaden the rich tapestry of Scotland's domestic and cultural landscape. Today we are fortunate to have Italian influence in our architecture, culinary experiences, arts, sport, academia and business. We recognise our citizens from all nations and their enduring influence on our day to day lives. There is good reason indeed for us to be proud that we are a society which has welcomed, integrated and celebrated the variety of cultures and nationalities which makes for a modern and forward-looking Scotland.

Sir Eduardo Paolozzi has long been an inspiration for many. A native of Leith and a proud Scot, his has been a magnificent career. He has touched the lives of many through his work – amongst them scholars and artists who have pored over his oeuvre; visitors to national and municipal galleries in the UK and beyond; commuters and tourists passing through Tottenham Court Road Tube Station and encountering his tiled murals; and those who visit, pass by and enjoy his public sculptures at sites across the UK. A pioneer of the Pop Art movement, he shouted a modernity which brought both the provinces and internationalism to swinging London and beyond. No mean feat for a boy from Leith.

And so, when asked to invite Royal Scottish Academicians to develop works inspired by Paolozzi, I never felt for one second that this would be an onerous task. I have been proven right. Some artists responded with new works as a result of Paolozzi's legacy and others suggested works which they had made in the past – directly inspired by contact with the artist or on encountering his work as impressionable youths. Stories came forth of working with Paolozzi, meeting with him, being taught by him and being encouraged by him. The machinations of creative activity, memory, impact of colour and weight of legacy all working in individual minds in studios across Scotland.

I am delighted to have played a very small part in assisting with this project and, in turn, enabling the resulting works to be shown at the Royal Scottish Academy. The project assists to celebrate and reinforce our own connection with Sir Eduardo Paolozzi, an Honorary Academician, and gives an opportunity to present Paolozzi works from our Collection – A Recognised Collection of Significance for Scotland. However, and perhaps more importantly, it enables us to continue to celebrate the breadth of recognition for this great Scottish son and his tremendous impact on our cultural landscape.

<div align="right">
Colin R Greenslade, Director,

the Royal Scottish Academy of Art & Architecture
</div>

MICHAEL AGNEW RSA

I met Sir Eduardo Paolozzi briefly at the Royal College of Art when I was fortunate enough (as a student) to edition one of his etchings, facilitated by the printmaking department run at that time by Tim Mara. He came to assess the quality and consistency of my printing (I believe) mid-edition – like all great artists, he inspected the work at every stage of production; quality control so to speak. No pressure then?

I found the experience both exhilarating and slightly stressful to be honest; he was a man of few words but underneath driven by a creative reactor not short on fuel or imagination. An international Pop Art icon and Scottish to boot. Afterwards, my reflection centred on the questions I should have asked him about Scotland and identity but I never had the chance. Making this artwork has allowed me opportunity to visualise my interpretations of imagined answers to these unasked questions: somehow to reveal a response to Paolozzi the artist, his legacy, position and cultural identity in a contemporary Scottish context. I responded to the studio at SNGMA (which is fascinatingly real but not real, it isn't Paolozzi's studio after all, is it?) rather than public artworks or commissioned pieces. A studio space speaks more to me of private struggle, speculation, doubt, memories, experimentation, learning and order to some degree. For me a perfect opportunity to collage layered meanings to an existing scaffold or reality. My approach was to address issues of immigration and memory to prompt questions about identity and belonging in modern Scotland. The artwork was executed in the spirit of contemporary narrative invention.

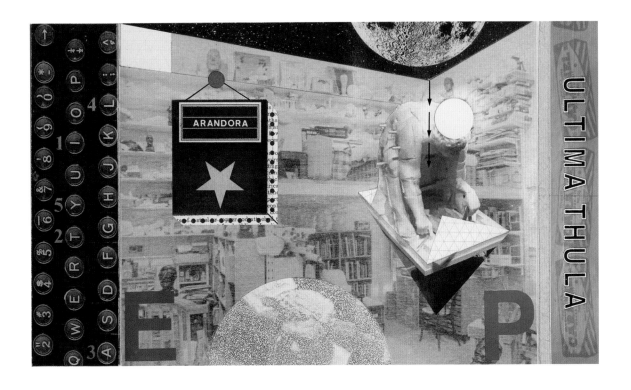

WILLIAM BROTHERSTON RSA

I met Eduardo Paolozzi on a number of occasions but I didn't know him well. The first time was with a group of students from Edinburgh College of Art (mostly from the Tapestry Department run by his friend Maureen Hodge) whom he had invited to visit his studio in Chelsea and afterwards to dinner in a Chinese restaurant; an example of his characteristic generosity towards students. Later, I met him a number of times when he visited Edinburgh College of Art as a visiting research professor. He would distribute postcards to those he was talking to, illustrating his current interests; the last time I saw him, he handed out postcards of the interiors of the Sigmund Freud Museum. When in Edinburgh, he always paid a visit to Wonderland, the model shop on Lothian Road.

I'm not sure when I was first aware of his work, but I remember hearing him talk and seeing his film, *History of Nothing*, in about 1963, in Cambridge. I remained particularly interested in the collaging of disparate familiar objects in the various aspects of his work, and the many plaster castings of objects that he made as a kind of ready-made vocabulary for current and future work.

My sculpture *Display of Objects*, which I think may owe something to my knowledge of Paolozzi's work, is intended to represent ideas about the familiarity and strangeness of objects. The separate components are cast from the plastic packaging used to protect things during transit rather than cast from the things themselves. Consequently they have a very specific formal character but no immediately recognisable identity, rather like mysterious objects in a museum display. The sculpture has the rather impassive sand-blasted finish, which I've admired in Paolozzi's sculpture *Mr Cruikshank*.

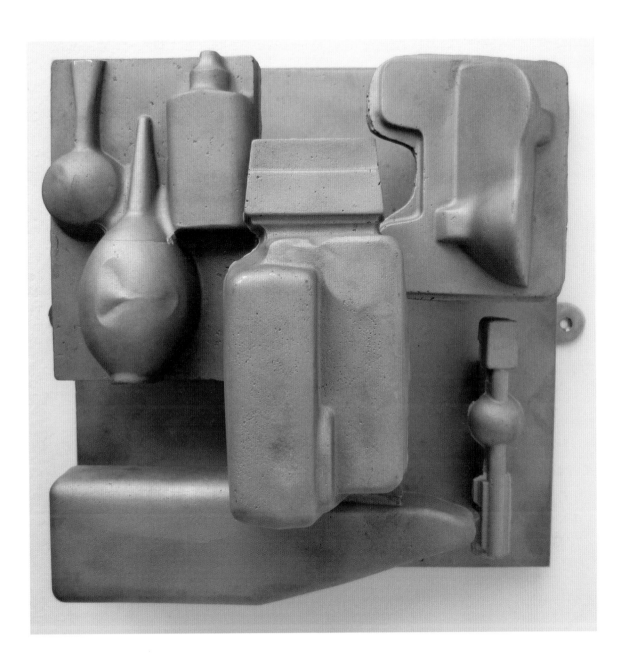

ALFONS BYTAUTAS RSA

The artwork produced specifically for this project mirrors Paolozzi's keen interest in printmaking, in particular screen-printing. My screen-printed textile 'banners' have been produced specifically in response to the innovative printed designs produced by Hammer Prints, a commercial enterprise Paolozzi set up early in his career in 1954 with his close collaborator, Nigel Henderson.

The two-man firm, based in rural Essex, produced printed textiles, wallpaper and ceramics. The then avant-garde designs referenced natural textures, 19th Century illustrations, graffiti and 'primitive' art and many were simply printed in black on white or onto plain coloured backgrounds.

Like the semi-abstract designs of Hammer Prints, my work can be viewed as being stylistically somewhere between abstraction and figurative art.

Recently I seem to have rediscovered the interests or obsessions that I enjoyed when I was younger. I was then fascinated with the uncanny and the fantastical – magic and illusion, Gothic fiction, horror films and so on. This naturally filtered into my interest in drawing and painting and I developed a liking for Surrealist art, which seemed to have a strong affinity with my other boyhood interests.

Decades later I have returned to explore these interests, particularly in the use of collage, which allows me to experiment with the free association of diverse images.

My aim is not to copy nature but to represent it as transformed by imagination, using methods similar to those employed by the Surrealists and by Paolozzi himself, who viewed his art as being an extension of radical Surrealism.

Paolozzi and the Electric City

The Sculpture Department at Duncan of Jordanstone College of Art, Dundee, in the 1960s was a fairly tough regime. Thoughts of developing a personal iconography took a back seat to the firm disciplines of figure study.

The discovery of Eduardo Paolozzi and his 'playgrounds of the mind' inevitably presented a rich target of enquiry for a young student seeking fresh and alternative directions. His fecundity and breadth of output continue, after decades, to provide a rich return. But it's primarily the sense of restless ongoing investigation evidenced in his legacy that offers, for me, the most reliable touchstone.

My work has always involved construction, whether in wood, steel or stone. Also, to some degree, collage, both on the flat and in the round. In recent years I have tended to address small works in number, usually focussed on one particular directional thrust. But it's only in the last few years that I have engaged with the application of colour on form.

Electric City was an undertaking that was underway some time before this current Paolozzi project emerged. It similarly comprises a number of studies: in this instance in what might be referred to as 'anti-form'; looking at how colour can deny or confirm otherwise 'rational' combinations of three dimensional elements.

The project was undertaken in the spirit of undermining what I already knew and usually sought to practise (the incorporation of harmony). Inevitably, as the process evolved, the rawness of colour use became more modified and restrained, signalling its end.

Out of this have grown other sculptural outcomes, possibly less aberrant but ones which would nonetheless have never been reached without the segue.

Art, for Paolozzi, was said to be 'a lively process rather than a professional activity'. I share his view; always did.

MICHAEL DOCHERTY RSA

Diary Notes for Eduardo

This work is based on conversations had over a number of years.

We first met when he came as Visiting Professor to the Department of Tapestry in Edinburgh College of Art where I was a tutor in drawing and painting. Later, he gave summer master classes in sculpture, when I was Dean of the Faculty of Art and Design.

During this time, we spoke frequently, and sometimes went for walks during the afternoon break. On one occasion, we went to Wonderland, a model and toy shop in Lothian Road. I offered to buy him a wee present and he chose a construction kit (a bombed-out building in Beirut).

A warm, thoughtful, generous artist – Eduardo often spoke of working across disciplines and the importance of drawing and metaphor.

He invited me to an exhibition of new work at the University of Cambridge. When I arrived, he told his friends that I had come down from Edinburgh, and he was delighted.

Like many others, I got gifts over the years, cards/posters/badges/ and a stunning plaster head.

When he died, there was a lovely reception in the Senior Common Room of the Royal College of Art, London, where he was remembered fondly. We had a good drink!

Ars Longa Vita Brevis.

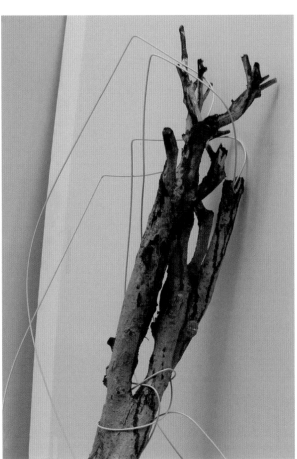
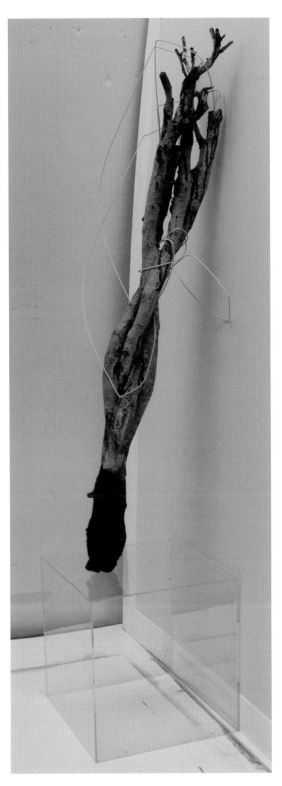

GRAHAM FAGEN RSA

Like Paolozzi, I'm interested in the formal representation of a person, a human through material; the creation of a three-dimensional sculpture of conscious nature.

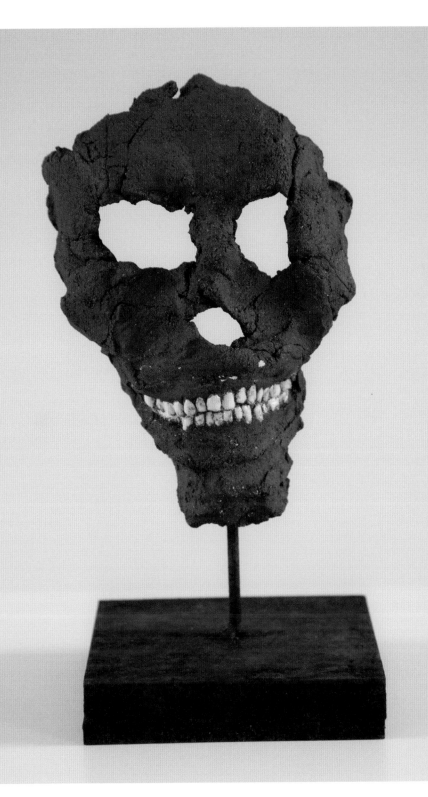

Space Craft

I guess that was my starting point... an image of a 1950s space craft which was the kind of Pop Art reference I saw occasionally in Paolozzi's work. The other was the sculptural object which was, I imagine, white offset with bits of colour. I realise very many of Paolozzi sculptures are cast in bronze. However, when I think of his sculpture, what comes to my mind immediately is the reconstruction of his studio at The Scottish National Gallery of Modern Art here in Edinburgh and all those wonderful white cast pieces in plaster.

What next comes to mind are some of his pop art prints which have an exciting use of colour. Colour, too, was used in some of his striking sculptures and the element of metaphor or his way of combining elements.

So... Spacecraft... wooden crosses become objects of flight?

The word 'Spacecraft' is written on the work in reference to Paolozzi's occasional use of text as part of sculpture or playfully in his prints. There is a play-on-words with Space and Craft as they are edited with a wash of gesso or clay – suggesting the making process – and also the inclusion of words within words:

Spa – 'a mineral spring considered to have health-giving properties.'

Aft – 'at, near, or towards the stern of a ship or tail of an aircraft.'

So, a flying icon bringing health giving properties, or simply a work in some ways inspired by the prints and sculptures of Paolozzi.

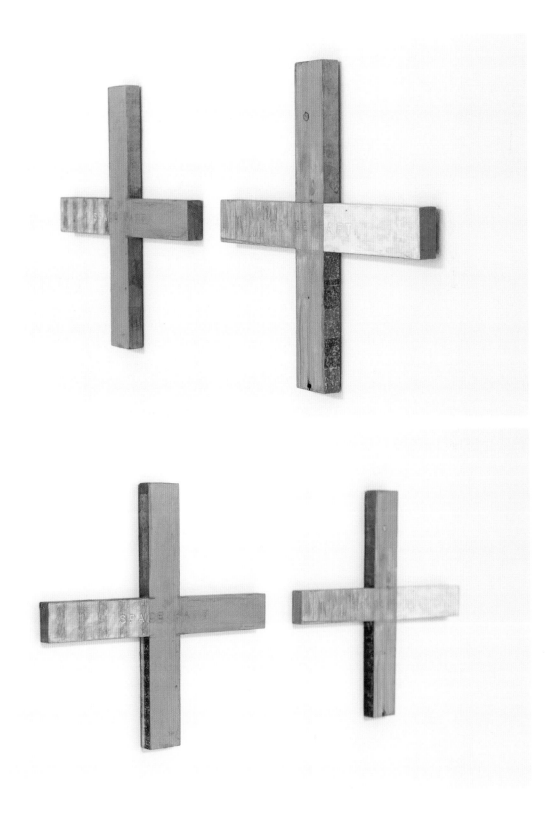

EILEEN LAWRENCE RSA

I first saw Paolozzi's work in the 1960s when I was a student at Edinburgh College of Art. This small work *Wet Transfer* 1967 was made in the first part of my post graduate year (1967–68). It incorporates scraps and transfers with gouache and pen and ink and was influenced by both these images from my childhood (I, like Paolozzi was born in Leith), and in particular by Paolozzi's prints and collages from that period.

I can still see aspects of this early influence in the way I work with paper and fragmentation.

Some 50 years later, by way of acknowledging Paolozzi's interest in print technology and his wider influence, I have had a digital print made of this collage.

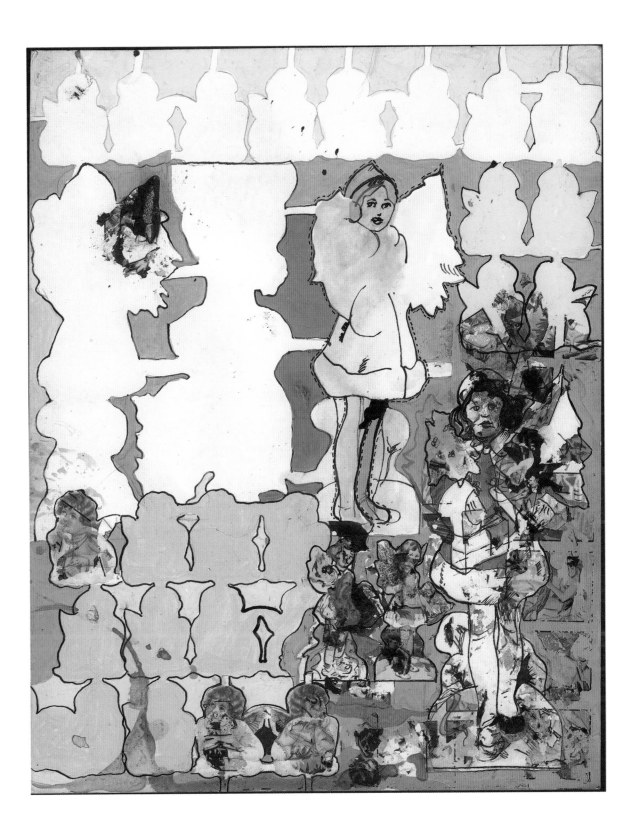

JIM PATTISON RSA

EPx45

EP stands for Eduardo Paolozzi and 45 refers to the number of images I've used in this print. EPx45 was designed digitally and printed as an archival digital print at Glasgow Print Studio.

I've greatly enjoyed looking at and researching Paolozzi's work afresh for this print and this process has reminded me again of his enormous ambition and achievement.

I've known his work since I studied art at high school, but until this recent reassessment I probably still wasn't fully aware of his remarkable contribution.

The images I've used refer to a broad range of Paolozzi's work – drawing, collage, print, mosaic, sculpture and textile design, and the way that I've constructed the print hopefully conveys something of the excitement, energy and wide ranging nature of his output.

The composition of EPx45, which divides and reassembles the selected 45 images is similar to the approach I've used in a series of works I'm currently engaged with – *Redivider*.

Redivider is one of the longest single English language palindromes in common usage and describes something that divides or apportions again. This ongoing series considers ways in which images, words, space and time might be divided, redivided and reassembled.

ALAN ROBB RSA

I met Eduardo Paolozzi several times while in my final year in the Painting School of the Royal College of Art in 1972. He was a visiting professor in the Ceramics Department. We met initially in the Queens Arms, a comfortable pub close to Kensington Gore. I was introduced by Davy Grant, a final year ceramist, and Douglas Gray, a painter who had recently transferred to Ceramics. Also in the company was David Queensbury, Head of Department. It was a very lively evening.

Davy Grant was to return to Lochinver to establish the Highland Stoneware Company; and Queensbury and Paolozzi became directors and stakeholders in the company.

It was an exciting time to be in London as an emerging painter.

In 1969, the new Hayward Gallery staged *Pop Art Redefined* along with a publication by John Russell and Susi Gablik. It was a fascinating comparison between Pop Art in New York and London.

A Richard Hamilton Exhibition opened at the Tate Gallery in 1970, followed in 1971 by the Paolozzi Retrospective. These major shows occupied the then newly opened Tate extension and had a massive impact on the art scene. That year was also the first survey exhibition of David Hockney at the Whitechapel and Michael Sandle at the Hayward.

A bus trip was organised in 1971 from the painting school to the Arnolfini in Bristol to see the first major Exhibition of Peter Blake, with Peter and Jan Haworth on board. Peter was my tutor in second year.

In my final year, I began to work directly from collages which were initially made from the comics of my childhood: the *Beano*, the *Topper* and the *Beezer*. I changed from oils to working in acrylic; carefully, faithfully replicating the collage on a much larger scale on canvas. During this process, revisions and new additions would begin to play a part.

And Later was the final work completed for my Degree Show.

The day after the opening, Eduardo Paolozzi appeared in the studio with an assistant and my painting was selected for his 'Choice of the London Post Graduate Shows' which he curated for the Greenwich Theatre Gallery. The selected works were mostly small and my large painting had the central position and a very positive review in the *Evening Standard*.

This work was to establish an approach and a body of work which culminated in the 1975 painting *A Positive Step towards the Negative*, which was purchased from the RSA Summer Exhibition for the Scottish Arts Council and is now in the McManus Galleries Collection, Dundee.

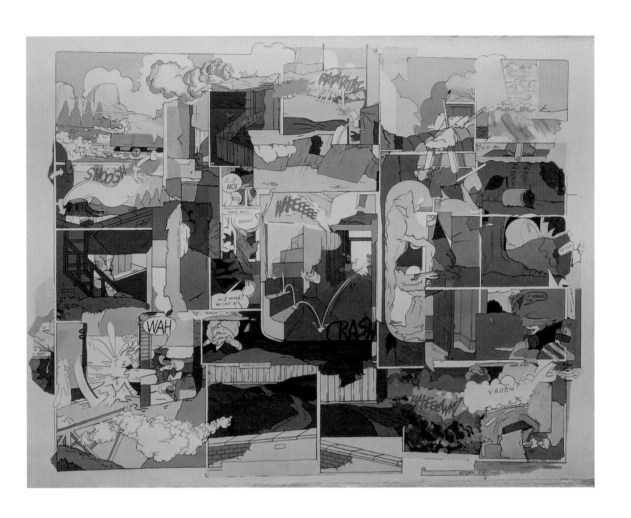

MICHAEL VISOCCHI RSA

In 2017 I created two new boxed cabinets, inspired by Giovanni Battista Piranesi's etchings of cross sections of subterranean Classical and Roman tombs.

These cabinets, entitled *The Tomb of Neil Armstrong* and *The Tomb of Charles Lyell*, display sections of imagined catacombs with chambers lined with objects upholstered in maps of their respective areas of exploration – for the Victorian geologist Charles Lyell, it is the Highland fault line of Scotland and, for the famous astronaut Neil Armstrong, the Moon.

Around the time I was completing these works, I was invited to create a new work responding to Eduardo Paolozzi for this publication and exhibition. It seemed an obvious step for me to commemorate the artist in this similar manner. In *The Tomb of Eduardo Paolozzi*, I have borrowed three elements, or recurring motifs, from Paolozzi's visual lexicon and imagined them as relics placed in an imagined tomb for the artist. In acknowledgement of the artist's own appropriation of found material, I have chosen elements which were themselves borrowed or collaged by Paolozzi from external sources such as books, magazines and textbooks. The elements I have incorporated are sourced from two of his screen prints from the 1970's. The upper chambers show a pie chart and half colour wheel from *BASH*, a limited edition print which accompanied his retrospective at the Tate in 1971. The lower chamber shows a palindromic form borrowed from *Four German Songs* (1974–76).

Metal Maus Musac Mask

Expanded timeline for: METAL MAUS MUSAC MASK

1969: My first encounter with a body of Eduardo Paolozzi's sculpture was when he was the invited artist in the SSA exhibition. Included was *Gexhi* (1967), given by Paolozzi to the SSA and subsequently purchased by Ian McKenzie Smith for Aberdeen Art Gallery. The 100 sheets from Moonstrips *Empire News*, (1967), published by Alecto and screen printed at Kelpra were projected in the gallery.

1972: Introduced by its curator Robin Spencer to Paolozzi's Krazy Kat Archive at that time held at the University of St. Andrews.

1982: A meeting with Isobel Spencer (Johnstone) in her Edinburgh kitchen to discuss her catalogue essay for the exhibition *4 North East Artists* at the Fruitmarket Gallery was enhanced by the presence of Paolozzi's screen-print *Who's Afraid of Sugar Pink and Lime Green* (1972), published by Bernard Jacobson, printed at Advanced Graphics.

1984: *Eduardo Paolozzi, Recurring Themes* was presented by the Scottish Sculpture Trust at the Royal Scottish Academy for the Edinburgh International Festival with a publication edited by Robin Spencer.

1985: A first meeting with Joe Studholme of Editions Alecto in London. This acquaintance was renewed at the opening of *Editions Alecto, A Fury of Prints*, at the City Art Centre, Edinburgh (2003).

2001: Mark Hunter found an empty portfolio partially buried in a Dundee basement. Some years later this was identified as having contained the 12 screen-prints of Eduardo Paolozzi's *As Is When* (1964–65), published by Alecto and printed by Kelpa.

2016: After identifying the folio, a project was initiated to produce 12 new prints for the folio in response to Paolozzi. This is nearing completion with six artists making two prints each: Delia Baillie, Paul Harrison, Mark Hunter, Rachel Lee, Arthur Watson and Peter Yearworth.

From my initial idea of an image on one sheet and text on the other, my response to the project has expanded to, at the time of writing, five editioned images and three editioned texts along with some 15 unique variations. A further offshoot from the text sheets was the double print, *A Gate to Metal Hell, Verso & Recto*. Drawing from Paolozzi's title, *The Metalization of a Dream*, the text explores various genres of metal music while the images reference recently discovered early prints based on weaving patterns fused with the mouse head adopted from Paolozzi's appropriation printed on the *As Is When* portfolio.

Assistance with Metal Maus and Metal Hell prints: Paul Harrison, Mark Hunter & Peter Yearworth.

BLACKENED DEATH METAL · UNBLACK METAL · FUNERAL DOOM METAL · DARK METAL · NATIONAL SOCIALIST BLACK METAL · SYMPHONIC METAL · CROSSOVER THRASH METAL · SATANIC METAL · DEATH 'N' ROLL · AVANT-GARDE METAL · PAGAN FOLK METAL · NEO-CLASSICAL METAL · MELODIC METAL CORE · DOOM METAL · DEATH METAL · WAR METAL · MELODIC DEATH METAL · NU METAL · CELTIC FOLK METAL

Biographies

Editors

CHRISTINE DE LUCA writes in English and Shetlandic, her mother tongue. She was appointed Edinburgh's Makar for 2014–2017. Besides several children's stories and one novel, she has had seven poetry collections and four bilingual volumes published (French, Italian, Icelandic and Norwegian). She's participated in many festivals here and abroad. Her poems have been selected four times for the Best Scottish Poems of the Year (2006, 2010, 2013 and 2015) for The Scottish Poetry Library online anthologies.

CARLO PIROZZI is currently a Teaching Fellow at the Italian Department of the University of Edinburgh. His main research interests are language teaching methodologies, Diaspora Studies (in particular, Italian migration to Scotland), contemporary Italian poetry and literature and the visual and performing arts. He is the coordinator of the 'Italo-Scottish Research Cluster' at the University of Edinburgh.

In addition to this, he initiates and develops creative interdisciplinary projects involving universities, public and private cultural institutions, as well as collaborations between artists from Scotland and Italy.

For Luath Press, he has published *Like Leaves in Autumn. Responses to the War Poetry of Giuseppe Ungaretti* (co-edited with Katherine Lockton, Edinburgh: Luath Press, 2015). Other relevant publications are a photographic diary of the journey of an Italo-Scot travelling from Edinburgh to Cassino, in Italy, after the Second World War, *No-Where-Next | War-Diaspora-Origin. Dominic Scappaticcio. A Journey, 1946–1947* (edited by Federica G Pedriali and Carlo Pirozzi, Ravenna: Longo, 2015); and a recent reprint of powerful novel-memoir *Wandering Minstrel* written by an Italo-Scot, Eugenio D'Agostino, under the pseudonym Cagliardo Coraggioso (edited by Carlo Pirozzi, UK: Amazon, 2018; first edition 1938, Oxford University Press).

In 2014, he won a Special Jury Prize in the Edinburgh International Film Festival's Short Film Challenge for the film *Coral Red*, which he wrote and co-directed.

Translator

FRANCESCA ROMANA PACI is Professor Emeritus of English Literature and Postcolonial Studies at Amedeo Avogadro University of Oriental Piedmont, in Northern Italy. Her main areas of interest are Romanticism, Modernism and Contemporary Studies. She has written extensively on poets and translated into Italian poems by Smart, Coleridge, Byron, Mangan, Joyce, MacNeice, Heaney and Christine De Luca.

Authors

DAVID CLARKE was Keeper of Archaeology, National Museums Scotland, for 30 years until 2011. He was Head of Exhibitions for the Museum of Scotland Project. He is currently a Visiting Professor at UCL and an Honorary Research Fellow in Edinburgh College of Art.

JUDITH COLLINS was Senior Curator of 20th Century British Art at the Tate for 15 years. She is an award winning author of numerous books on sculpture, and is currently preparing the catalogue *raisonné* of Eduardo Paolozzi's metal sculptures.

VIVIAN FRENCH has established an enviable reputation as a popular children's writer, one with whom illustrators love to collaborate. She is involved in schemes to encourage both new illustrators and young readers. Vivian was awarded an MBE in the 2016 Honours List for services to literature, literacy, illustration and the arts.

COLIN R GREENSLADE is Director at The Royal Scottish Academy of Art and Architecture, Edinburgh. He is a curator, writer and collector. Originally from the North East of Scotland he is now based in Edinburgh and Fife.

BILL HARE is Honorary Fellow in Scottish Art History at the University of Edinburgh. He is author of *Contemporary Painting in Scotland* (1992) and *Facing the Nation: The Portraiture of Alexander Moffat* (2018).

LIV LAUMENECH works with the University of Edinburgh Art Collection as Public Art Officer. Alongside the care and development of art on campus she is responsible for developing the Paolozzi mosaic project.

DUNCAN MACMILLAN, art critic and art historian, is Emeritus Professor of the History of Scottish Art in the University of Edinburgh. He is art critic of the *Scotsman* and has published and lectured widely on art and artists.

KIRSTIE MEEHAN is Archivist at the Scottish National Gallery of Modern Art, where she has worked since 2006. She cares for over 130 archive collections of 20th and 21st century art and artists – including Eduardo Paolozzi, Ian Hamilton Finlay and Joan Eardley – in addition to a world class collection of Dada and Surrealist publications.

FIONA MENZIES is an Archivist at the Scottish National Gallery of Modern Art where she looks after archival material held by the gallery, including Paolozzi's extensive archive. Before starting at the Galleries in 2017, Fiona worked as a Project Archivist for the University of St Andrews, Special Collections.

ANDREW PATRIZIO is Professor of Scottish Visual Culture in the School of History of Art (Edinburgh College of Art at the University of Edinburgh). He publishes widely on Scottish art and on the environmental humanities. Paolozzi featured strongly in his PhD on art and industry in Scotland (1994).

FIONA PEARSON was a Senior Curator at the Scottish National Gallery of Modern Art 1983–2008. She worked with Paolozzi from 1994 to 2004 on the studio reconstruction and cataloguing the studio contents, subsequently curating the *Paolozzi at 80 Retrospective Exhibition* in 2004 at Scottish National Gallery of Modern Art Two. She wrote an appreciation of Paolozzi 's life for *The Sculpture Journal*, October 2005 and an article on Paolozzi and Freedom for the *Scottish Society for Art History Newsletter*, Winter 2013.

ROBIN SPENCER studied at Manchester and the Courtauld Institute before joining St Andrews University in 1969, eventually becoming its first chair in Art History. He was a leading specialist on the work of Eduardo Paolozzi, editing the magisterial *Eduardo Paolozzi: Writings and Interviews* (Oxford University Press, 2000), curating *Eduardo Paolozzi, Recurring Themes* (Royal Scottish Academy, 1984) and acting as Director of the 'Krazy Kat Arkive' when it was held at St Andrews. He died in 2017.

ELLY THOMAS is an artist and independent scholar. She is currently developing aspects of her doctoral research for a book to be published by Routledge, *Play and the Artist's Creative Process: The Work of Eduardo Paolozzi and Philip Guston.*

LUCY WEIR is a specialist in modern dance and performance. Her research interests span the fields of live art, theatre and dance to queer culture and gender studies. Lucy received her PhD from the University of Glasgow in 2013 and held several teaching and research fellowships before taking up her post at the University of Edinburgh.

Map designer

HELGA PAVELKOVA is a versatile and innovative illustrator based in Bratislava, Slovakia. She completed a degree in illustration at Edinburgh College of Art. Her work includes self-initiated and commissioned illustration work as well as some graphic design. She particularly enjoys creative collaboration for a specific purpose, particularly stories relating to real people.

Additional photographers

RAY BIRD is a filmmaker and photographer based in Edinburgh. He has worked in film, television and theatre, and has produced several

films and prints on the social history of the city. He also works in commercial aerial photography and filmmaking. For more details, please see http://www.rarebirdmedia.com/

LUIGI GIANNETTI is an Italian photographer who lives in Picinisco, a village nestling in the stunning setting of Frosinone Province. It is part of the Lazio region in the centre of Italy, which lies between the Comino Valley and the National Park of Abruzzo, Lazio e Molise. Paolozzi's parents came from the same area of Italy.

DAVE SANDS is a mature student at Glasgow School of Art studying Fine Art Photography. He is currently exploring the impact of edges and reflections interrupting the space between the camera and the subject resulting in abstract images. His current areas of focus are Paolozzi's Millennium Window and the Assynt landscape.

RSA Artists

MICHAEL AGNEW attended Gray's School of Art, Aberdeen (1986–90) and the Royal College of Art, London (1990–92), where he undertook a MA in Printmaking. Since 1993 he has been Lecturer in Printmaking at Gray's School of Art.

WILLIAM BROTHERSTON studied History and Fine Art at Cambridge University (1962–65) and Sculpture at Edinburgh College of Art (1965–71). His sculptural practice centres on exploring the expressive possibilities of everyday subjects. Until retirement he was Senior Lecturer in the School of Sculpture, Edinburgh College of Art.

ALFONS BYTAUTAS attended Edinburgh College of Art to study Painting and Drawing. In 1983 he studied at Atelier 17, the Parisian studio of painter and printmaker Stanley William Hayter. From 1979 to 2009 he was Master Printer at Edinburgh Printmakers where he developed pioneering printmaking techniques. Since 2013 he has been Principal Technician in the Faculty of Arts, Design and Social Sciences, Northumbria University, Newcastle upon Tyne.

DOUG COCKER studied at Duncan of Jordanstone College of Art and Design, Dundee, and had his first major solo exhibition at the Fruitmarket Gallery, Edinburgh, in 1977. He has held the position of Lecturer at Nene College, Northampton, and Gray's School of Art, Aberdeen, and has won over 40 commissions for public sculpture projects throughout the UK.

MICHAEL DOCHERTY was Dean of Faculty of Art and Design at Edinburgh College of Art. His work is held in collections including Edinburgh College of Art and Art in Healthcare.

GRAHAM FAGEN studied at Glasgow School of Art (1984–88) and then at the Kent Institute of Art and Design (1989–90). His practice combines video, sculpture, performance and sound. In 2015 Fagen represented Scotland at the 56th Venice Biennale. He is Senior Lecturer at Duncan of Jordanstone College of Art and Design, Dundee.

PAUL FURNEAUX studied at Edinburgh College of Art (1982–87) and at Tama Art University, Tokyo (1997–2000). Furneaux works with the traditional Japanese woodblock printing process of *mokuhanga*. His practice has revitalised this ancient print-making process.

EILEEN LAWRENCE studied at Edinburgh College of Art. Lawrence's work centres on the evocation of place and is held in collections including the British Museum, the European Parliament and the Arts Council of Great Britain.

JIM PATTISON studied Architecture and then Drawing and Painting at Duncan of Jordanstone College of Art, Dundee. His work uses digital technology to interrogate received knowledge and is held in collections including Glasgow Museums, Creative Scotland and Standard Life.

ALAN ROBB attended Gray's School of Art, Aberdeen (1964–69) and the Royal College of Art, London (1969–72). He is Emeritus Professor of Fine Art at Duncan of Jordanstone College of Art, Dundee. His work is known for reinventing religious and classical iconography represented with technical virtuosity.

MICHAEL VISOCCHI studied Sculpture at Glasgow School of Art. Principally concerned with fabricating in wood, metal and manmade materials, Visocchi's practice relates to themes about the landscape and architecture.

ARTHUR WATSON attended Gray's School of Art, Aberdeen (1969–74), before working as an artists' printer at the newly established Peacock Printmakers, Aberdeen. An interest in ephemeral elements within Scottish culture informs Watson's work. He is currently Senior Lecturer at Duncan of Jordanstone College of Art and Design, Dundee, and President of the Royal Scottish Academy.